FASHIONISTA

A CENTURY
OF STYLE ICONS

"I think of words like Beauty, Charm, Dreams, Wonderful—
but they are not enough for such a gallery of portraits, such a
representation of global power and influence..." Nino Cerruti

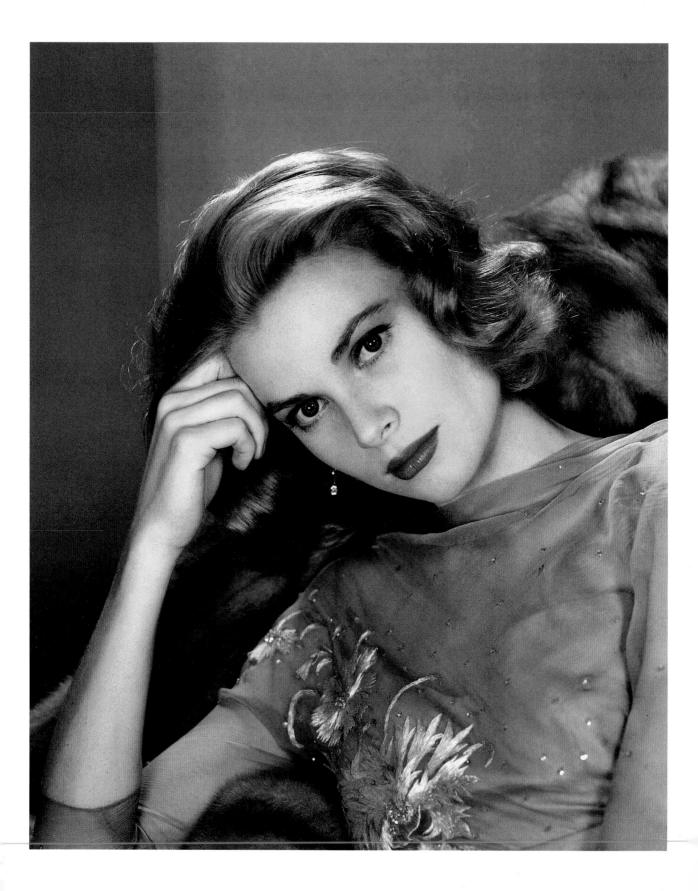

SIMONE WERLE

FASHIONISTA

A CENTURY
OF STYLE ICONS

PRESTEL
MUNICH | BERLIN | LONDON | NEW YORK

Front cover: Audrey Hepburn, undated, (PELE COLL/STILLS/laif)
Back cover: Left column: Dita von Teese (see p. 103), Scarlett Johansson
(see p. 117), Gwen Stefani (see p. 75), Rania Al Abdullah of Jordan (see p. 24)

Audry Hepburn ™ Trademark and Likeness
Licensed by Sean Ferrer and Luca Dotti

Prestel would like to thank

 and corbis.

for their kind cooperation

Prestel Verlag
Königinstraße 9
80539 München
Tel. +49 (0) 89 242 908-300
Fax +49 (0) 89 242 908-335

Prestel Publishing Ltd.
4 Bloomsbury Place
London WC1A 2QA
Tel. +44 (0) 20 7323-5004
Fax +44 (0) 20 7636-8004

Prestel Publishing
900 Broadway. Suite 603
New York, N.Y. 10003
Tel. +1 (212) 995-2720
Fax +1 (212) 995-2733

www.prestel.com

The Library of Congress Control Number: 2009921888

British Library Cataloguing-in-Publication Data: a catalogue record for
this book is available from the British Library. The Deutsche Bibliothek
holds a record of this publication in the Deutsche Nationalbibliografie;
detailed bibliographical data can be found under: http://dnb.ddb.de

Project management by Claudia Stäuble
Translated from the German by Paul Aston, Rome
Copyedited by Jonathan Fox, Barcelona
Cover and design by LIQUID, Agentur für Gestaltung,
Augsburg
Layout by WIGEL
Production by Astrid Wedemeyer
Lithography by ReproLine Mediateam
Printed and bound by Tlaciarne BB, spol. s.r.o.

Printed in Germany on acid-free paper

ISBN 978-3-7913-3936-8

I do not have the image of a single emblematic woman posing in my clothes, or rather I have them all, all these images of women. They are, moreover, the faces, the style icons that leave their scented trail in each of my collections without any of these portraits being the inspiration for a collection. I confess it, here, I do not surrender to an iconic presence, I do not have a queen of whom I dream every day and honor when I work.

I like an odd word, a bit erudite but curious: I like the word "acheiropoiete," a term applying to pictures which just appear, icons which miraculously come into view, not coming from the hand of man, such as the face of Christ or the Virgin. I think that these women's faces—these icons some among us take as a source of inspiration— these are precisely acheiropoietic pictures. They populate the imagination. My imagination does not form one image, but probably recomposes these icons into an oblique contour, embodied by numerous faces. I believe that these modern icons assume a religious essence, like biblical appearances.

I do not belong to a single face, but I belong to several icons, past or present; these last haunt the perimeter of a hair band, the purity of a hip line, the form of a negligee, the smoothness of silk. Perhaps my clothes pay tribute as much to the distant and soft allure of Sofia Coppola as to the raven hair of a past heroine, the actress Louise Brooks... However, I believe that I do not only have one face; I probably have several faces, several appearances. But these ghosts, genial and reassuring, often take their leave again.

DRIES VAN NOTEN

"Women who have self-confidence and are secure in their own strength will find clothes in which they discern their own personalities." Christian Lacroix

They impress with glamour, enchant with elegance, and provoke with daring combinations. What fashionistas wear today is copied tomorrow throughout the world. Their outfits fill the pages of the international fashion press, and their looks influence what's inside thousands of closets. And yet it is not necessarily just clothing that makes a woman a fashionista. True style icons stand out for more than just a pretty wardrobe. It takes more to bring fashion to life—specifically an appetite for a style of one's own.

Fashionistas have mastered the art of being fashionable while remaining themselves. What they wear is spectacular, but how they wear it catches the eye even more. They play with their look; they know the rules of fashion inside and out and yet (or perhaps for that reason) are not afraid to break them at just the right time. But above all they choose outfits that suit their own nature—they take account of the zeitgeist, but even more of themselves. It is not surprising therefore that no fashionista is like any other. The finest thing about personality is its uniqueness. Regardless of whether they're androgynous or sexy, elegant or wild, natural or femmes fatales—fashionistas are style icons who are also aesthetically at home in character. The result is an authentic style that, at the right time and the right place, can trigger a fashion revolution.

Its influence is only evident post hoc. From a distance, the style of some fashionistas seems like the mood of a fashionable moment, a stylistic heartbeat. Others manage to influence whole generations with their looks, immortalized in the hall of fame. Both are equally important for fashion. That's because only in their totality, with all their fashionable facets, do fashionistas prove that good style is one thing above all—a journey to oneself, regardless of the way that takes you.

SIMONE WERLE

THE CL

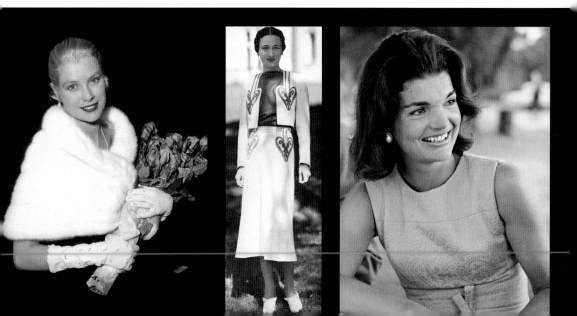

ASSICS

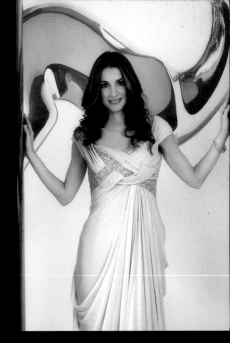

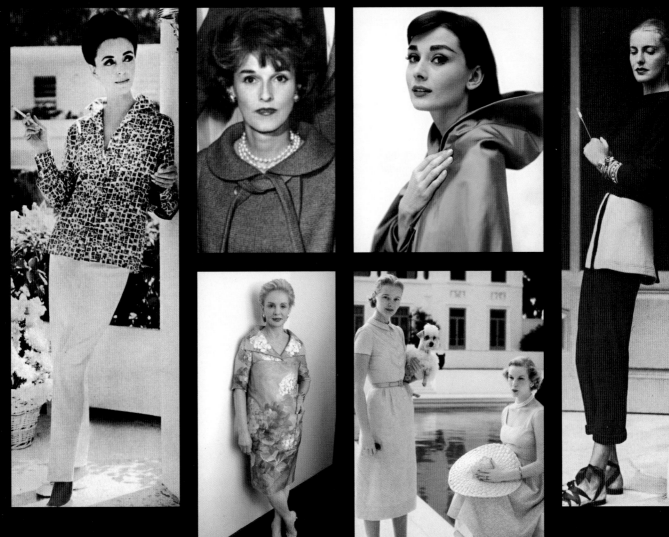

JACQUELINE KENNEDY ONASSIS

"Her style was the style of greatness, and because she was unrivalled, her influence was felt around the world." Carolina Herrera

Jacqueline Kennedy was the First Lady of First Ladies. She brought more than just fashion to the political arena. She gave the world a style so very much her own it couldn't be named after anyone else.

In the early sixties, the President's young wife offered a welcome alternative to the pretentious style of the postwar years—the Kennedy look was both fresh and conservative, to some extent an adult version of the youthful style of the time. The basic features of her look, soon copied a thousand times over, were straight, loosely cut dress coats, and sleeveless shift dresses with matching coats. By generally avoiding patterned fabrics in favor of muted cream or pastel shades, the delicate brunette accentuated her already almost aristocratic aura. Accessorizing sparingly, gloves in matching colors, pearls, and plain clutch handbags were the First Lady's discreet companions. Only in the mid-seventies did Jackie Kennedy—by then Jackie O.—add XXL-size sunglasses and outsize bags to her classic fashion portfolio.

The success of the Jackie style was no accident. The First Lady's wardrobe came at enormous expense; she and French fashion designer Oleg Cassini painstakingly choreographed each outfit. The duo's greatest coup was the pillbox—a flat, little round hat sitting on the back of the head bearing a faint resemblance to a nurse's cap. On Kennedy, the pillbox looked like a crown—she a queen.

In November 1963, Jacqueline Kennedy suddenly became the most famous widow in the world. The image of her in a pink Chanel suit spattered with the blood of her assassinated husband is unforgettable. Kennedy didn't change for hours. She wanted the public to see what had happened. As so often, Jackie spoke through her clothes—and her message is still understood today.

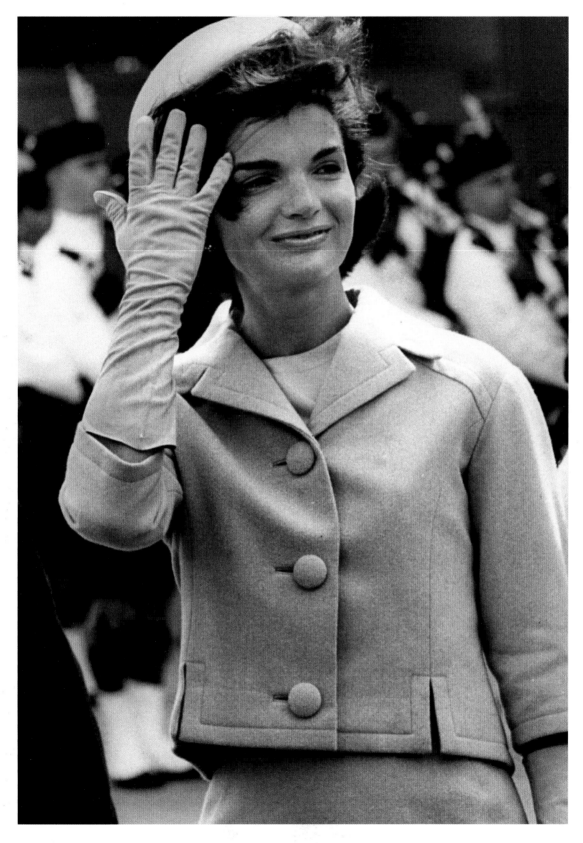

Jacqueline and
John F. Kennedy
arrive in Dallas,
Texas, 1963

Jacqueline
Kennedy, 1961

>>
At Heathrow
Airport before
catching a flight
to New York,
1970.
A rare sight:
Jacqueline
wearing a
patterned shift
dress during a
state visit to
India, 1962

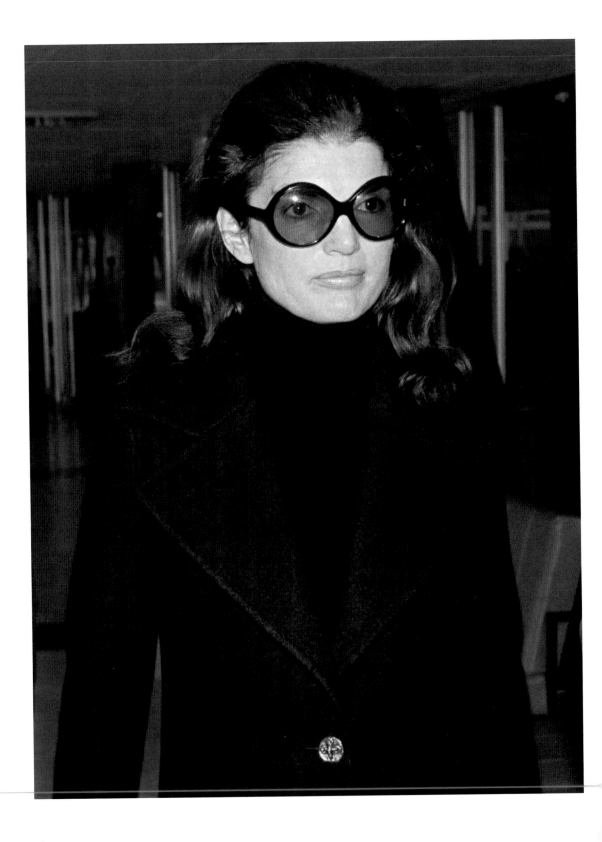

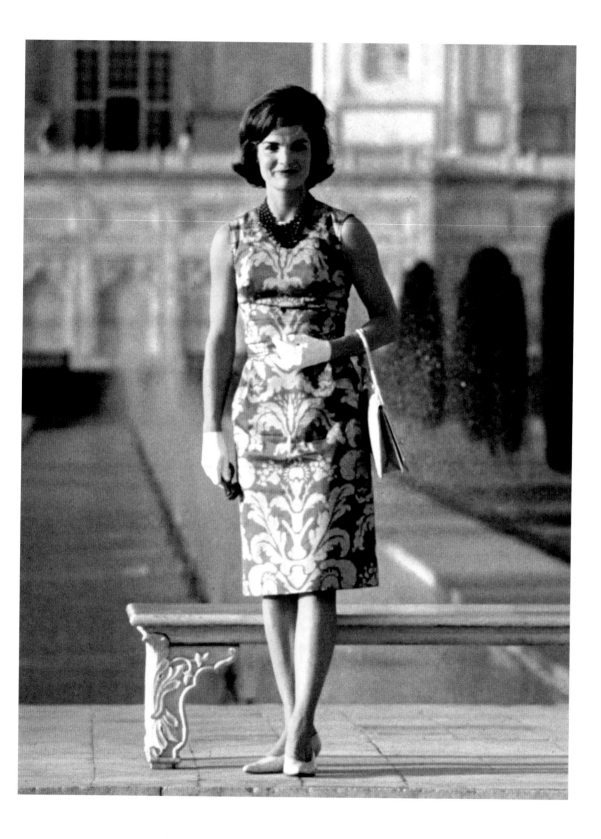

THE DUCHESS OF WINDSOR

"A woman can't be too rich or too thin."

A fairy tale could hardly be more romantic—a king meets his great love, an American double-divorcee, and gives up his throne in order to have the new woman at his side. The story of Edward, Prince of Wales, and Wallace Warfield Simpson (the later Duchess of Windsor) was not only one of the most talked-about liaisons of the twentieth century (and without which, Elizabeth II might never have been queen), but also produced one of the most notable style icons of its time.

Her greatest duty, or at least the way the Duchess of Windsor herself saw it, consisted of entertaining her (now idle) husband and propping up his pride. Though not endowed with natural beauty, she was nonetheless obliged to stop conversation upon entering a room. To live up to the job, the newly fashioned Duchess, who was not at any rate given to thrift, spent freely. The luggage for her honeymoon alone contained sixty-six dresses with matching shoes and accessories. Every year she often had over one hundred couture dresses and combinations made, generally by her favorite fashion designer Mainbocher (who also designed her slim, blue bridal dress), Chanel, Dior, Givenchy, and Schiaparelli. If she took a particular liking to a garment, she immediately ordered the same style in several colors and fabrics. And although she acquired a completely new wardrobe for every season, she was not a woman to follow the fashion. The Duchess preferred plainly tailored clothing that accentuated her slim figure. She was more daring with her accessories, mixing priceless jewels she got from her husband (the Duke decreed that after her death the stones should be removed from their settings so that no one else would be able to wear the jewelry) with modern costume jewelry. The Duchess was a perfectionist for the details: she had her hair done three times a day and knew from what angle she was most photogenic. The Duchess of Windsor was undoubtedly up to the task she had set herself. Although she did nothing worth mentioning outside fashion, she was certainly one of the great style icons. For more than forty years, no list of best-dressed women was complete without her.

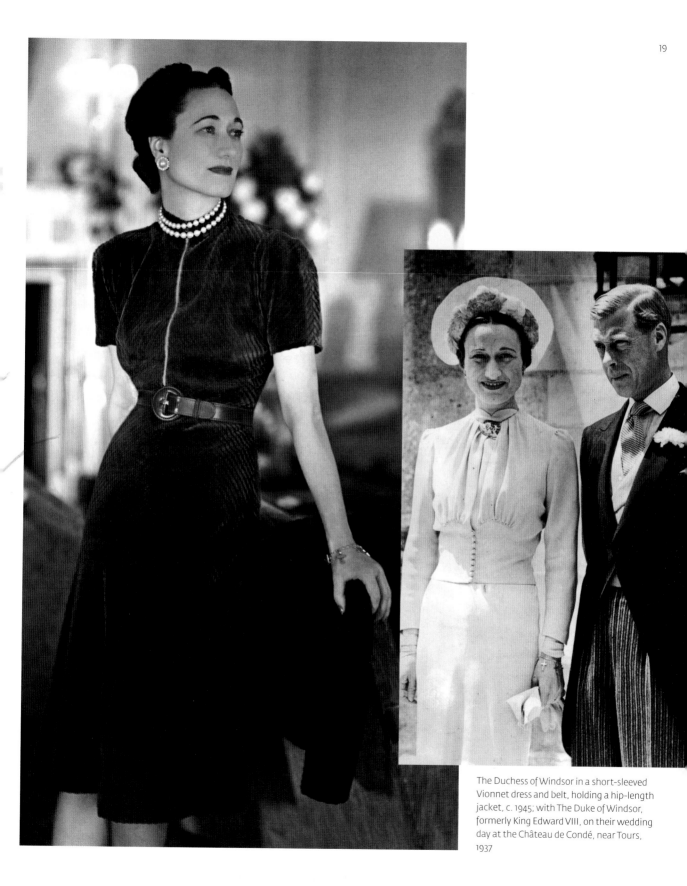

The Duchess of Windsor in a short-sleeved Vionnet dress and belt, holding a hip-length jacket, c. 1945; with The Duke of Windsor, formerly King Edward VIII, on their wedding day at the Château de Condé, near Tours, 1937

AUDREY HEPBURN

"My look is attainable. Women can look like Audrey Hepburn by flipping out their hair, buying the large sunglasses and the little sleeveless dresses."

A taxi drives along the empty streets of a New York morning. It stops outside Tiffany's, where a slender young woman gets out. She wears a little black dress and dark sunglasses and carries an ordinary paper bag in her hand. She catches sight of the display in the shop window, thoroughly interested yet with no intention to buy. She takes a croissant and a cup from the bag, casually sinks her teeth into the croissant, takes a sip of coffee, and finally sets off for home on foot. The opening scene of *Breakfast at Tiffany's* lasts under two and a half minutes but nonetheless made fashion history. This is due less to the fabulous dress than to the woman wearing it—Audrey Hepburn.

"The word 'elegant' was invented for her." Dominic Dunne

Born in Belgium, at the beginning of her career Hepburn did not in the least match the Hollywood ideal of beauty. She had the almost androgynous figure of a trained dancer, dark hair with a simple coiffure, and prominent eyebrows—all features quite alien to the overt sex appeal of Lana Turner or Marilyn Monroe. But Audrey Hepburn had a much rarer quality—natural charm, and she knew how to make the most of it. With her favorite couturier Hubert de Givenchy, to whom she remained loyal all her life, she developed a style of simple lines, high waists, and straight tailoring. Kitten heels and flats by Ferragamo underlined the delicate beauty of the doe-eyed brunette. What she radiated was a sophisticated but unpretentious elegance that represented a much-sought-after antithesis to the opulent blonde look of Hollywood. As it happens, one of the legendary Little Black Dresses from *Breakfast at Tiffany's*, privately owned by the Givenchy family, was sold to an unknown bidder at Christie's for $807,000—to date, the most expensive dress in the world.

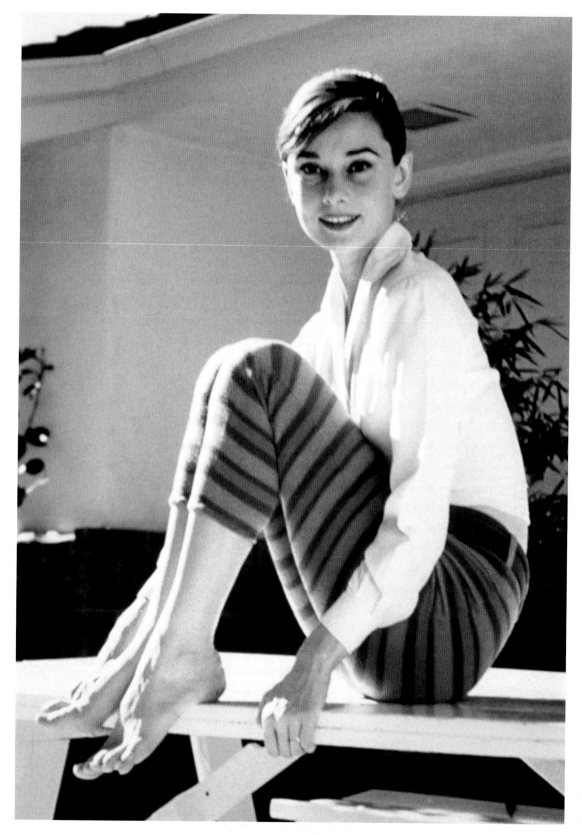

Audrey Hepburn
stops for
breakfast on
Fifth Avenue
during location
filming for
*Breakfast
At Tiffany's*,
directed by
Blake Edwards,
in which she
stars as Holly
Golightly.
New York, 1961

Audrey
Hepburn, 1960s

>>
Hepburn
reclining in a
black pantsuit
for the film
Sabrina, directed
by Billy Wilder,
1954

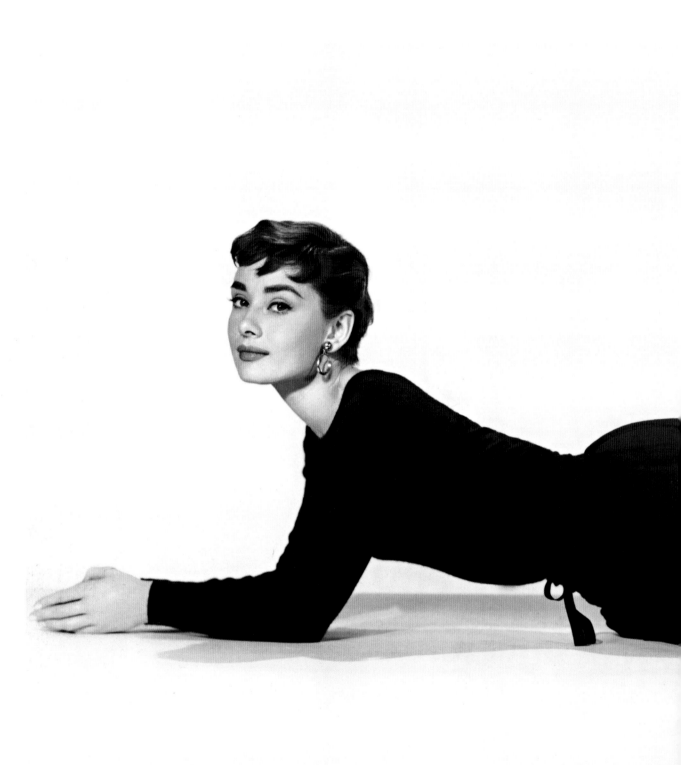

RANIA AL-ABDULLAH OF JORDAN

Don't be taken in by her doe eyes—Rania of Jordan is no Bambi; the young queen has the courage of her convictions. At least as unusual in an Arab ruler is her look, an intelligent mix of western chic and Arab glamour.

Born a commoner, at twenty-three she married Jordanian Prince Abdullah, and six years later became the youngest queen in the world. The $1.5m diamond diadem she wore at the coronation ceremony was a loan from her sister-in-law. But Rania soon drew attention to herself with a style of her own—the Muslim queen decided against the veil, instead adopting a very contemporary, feminine style. She combined strength with casual chic, light colors with soft tailoring, and is not afraid of outfits that emphasize the body. Even in political discussions, Rania prefers to wear a dress rather than a suit, and underlines her feminine appearance with undulating hair and the obligatory high heels. Her collection of designer bags (like Audrey Hepburn, she often goes for Givenchy) is famous to the point of notoriety.

This mother of four children doesn't want to look austere just to be heard. Nor does she need to. Rania of Jordan shows that despite having fun with fashion, you can also be serious.

Her style is to some extent the power dressing of the new millennium.

"She has the body of a model, and she holds herself like the queen she is—what more could you want?" Giorgio Armani

Having become an international media darling, Rania knows how to use her presence. She uses the press effectively on behalf of children and women, fighting especially for equal rights. Her very look is the first step in that direction. Rania's playful elegance is not only beautiful to look at, but also almost a political avowal of the new feminism and everything that goes with it.

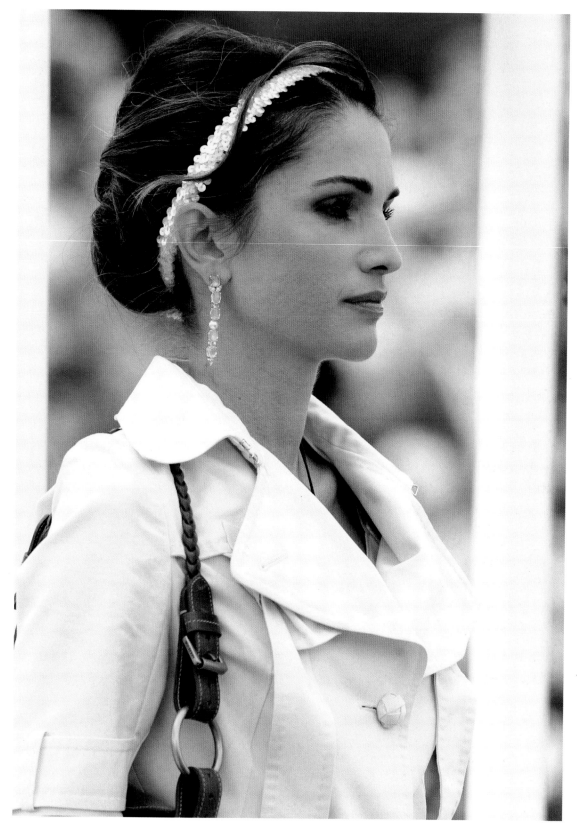

Rania
Al-Abdullah
of Jordan
attends a
gala dinner,
New York, 2007

Attending the
Sovereign's
Parade at the
Royal Military
Academy in
Sandhurst, 2006

GRACE KELLY

"Everything she wore appeared so elegant and was put together with such an assured sense of style, that she outshone anyone in her company—even her charismatic husband, Prince Rainier." Vogue

Millionaire's daughter, film star, and glamorous princess known as the "Ice Princess"—that was Grace Kelly. And she looked the part. Blonde and unapproachable, but at the same time full of passion and yearning, the actress and later Monegasque royal was full of enormous contradictions. Her chilly sex appeal soon made her the darling of Hollywood. In only four years, she not only won an Oscar and became Hitchcock's muse, but also notably outdid her female Hollywood colleagues with her unpredictability.

Her unmistakably fine style embodied the beauty ideal of the 1960s. The elegantly proportioned beauty favored Christian Dior's New Look, in which the emphasis was on a narrow waist with sweeping, feminine flared skirts. Kelly supplemented her graceful outfits with impeccably chosen accessories such as white gloves and dashing turbans. With her naturally regal bearing, she not only won the general public, but one of the most sought-after bachelors in Europe— Prince Rainier III of Monaco.

The most beautiful engagement present proffered to the princess-to-be was having Hermès rename one of his handbags after her. The Kelly bag, designed eighteen years earlier as a *sac à dépêches*, has the same timeless elegance as its namesake. The trapezoidal handbag soon became the princess's constant appendage—and still remains a coveted status symbol today. Equally memorable is her wedding dress, a white dream of Spanish lace and scented silk tulle designed by Hollywood costume designer Helen Rose.

Grace Kelly's biography between the bourgeoisie, the magic of Hollywood, and palace life is the stuff of fairytales. Only a happy ending was denied. Increasingly isolated, the princess died in a car accident in 1982, under circumstances never clarified. But her style, beauty, and glamour live on.

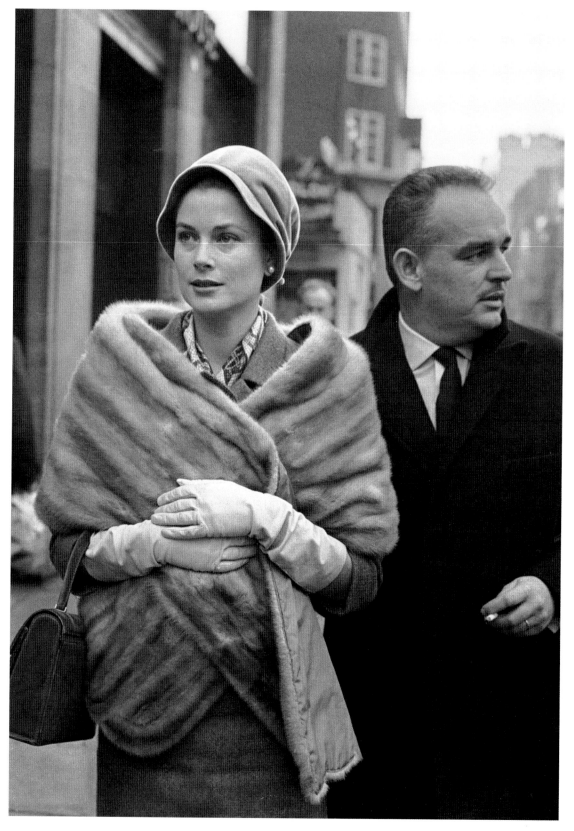

Grace Kelly, c. 1950s.

Princess Grace and Prince Rainier of Monaco shopping in London's West End, 1959

>>
Grace Kelly in a strapless gown with a sprig of flowers tucked into her bodice, Hollywood, 1954; and as Princess Grace of Monaco at the Cannes Film Festival, 1960

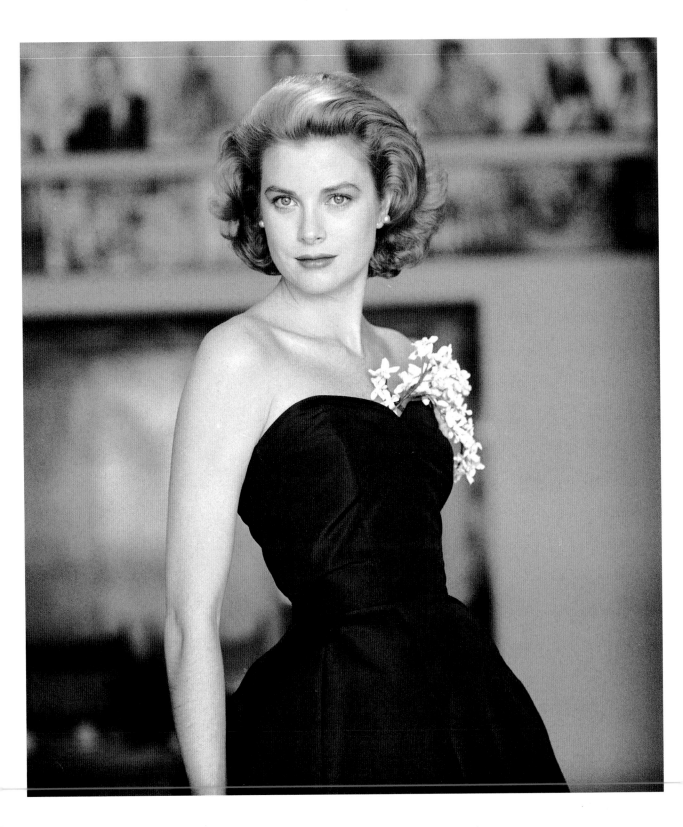

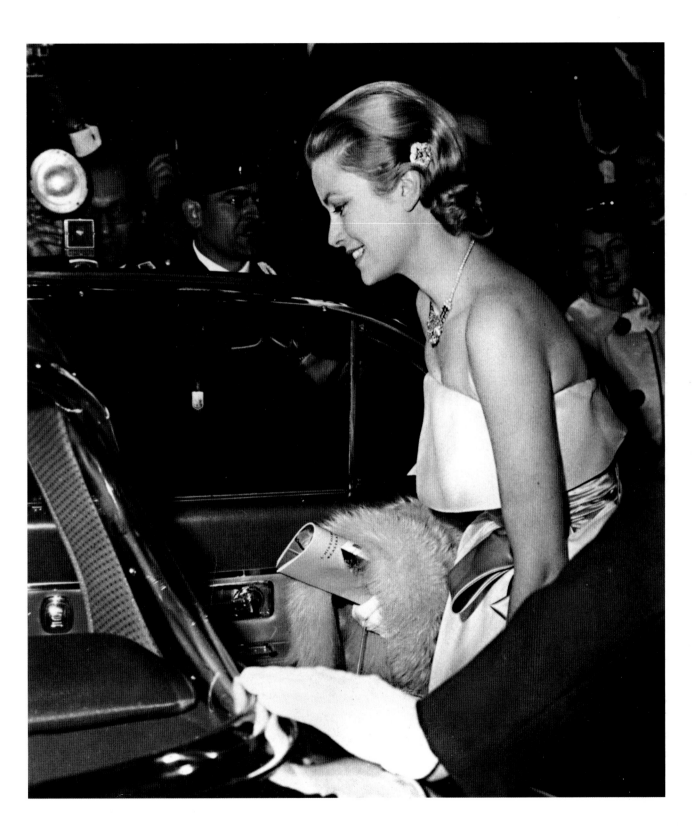

BABE PALEY

"Babe Paley had only one flaw: she was perfect. Other than that, she was perfect." Truman Capote

Babe Paley was in a class of her own. The brilliant social events of the charming New York hostess were legendary, her art collection (which included a number of Picassos, Cézannes, and Pollocks) was priceless, and her numerous residences decorated by Billy Baldwin were breathtaking. It never occurred to Barbara Cushing Mortimer Paley (as she was born) to leave any aspect of her life to chance—and certainly not her appearance.

When it came to updating her wardrobe, Paley, who married into enormous wealth her second time round, did not select the odd item or two but often an entire season's collection—without tying herself down to one designer. Her favorites included Chanel, Mainbocher, Givenchy, and Halston. And yet the former *Vogue* editor was far from having a stock designer look. She had her own style of sophisticated Park Avenue glamour mixed with cool insular elegance. Paley put great importance in immaculate makeup and a perfect hairdo—but saw no reason to dye her grey hairs. Her accessories, a daring combination of precious jewels and extravagant but less expensive costume jewelry, were combined with meticulous precision, always looking absolutely perfect. Babe Paley managed to be at the same time both timelessly elegant and innovatively modern. Her look was endlessly discussed in the fashion press and copied nationwide. Sighted once with her silk scarf wrapped round the handle of her bag, *Vogue* devoted an entire page to it. She appeared on the best-dressed list fourteen times and ultimately entered its hall of fame. Truman Capote declared her, along with Slim Keith, Gloria Guinness, and C. Z. Guest, one of his "swans."

And yet, as so often occurs, beneath the glossy exterior her world was anything but perfect. Paley suffered increasingly from the public pressure demanding perfection, from the countless affairs and ever-higher expectations of her husband, and Truman Capote's betrayal of their friendship when he used their confidential conversations as the basis for his book *Answered Prayers*. She began to smoke over forty cigarettes a day, and eventually died of lung cancer. Like her society events during her life, her funeral and memorial service were beyond compare. Not surprisingly, since she planned them herself.

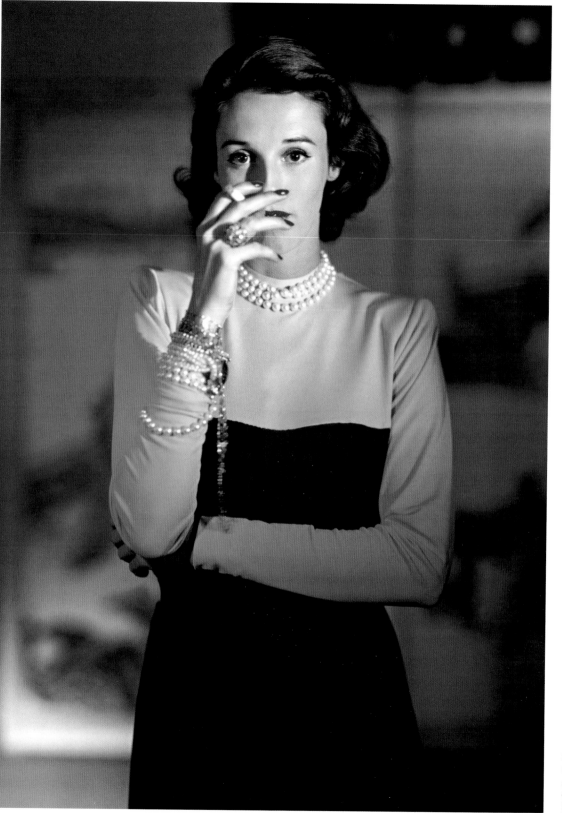

Babe Paley
wearing a blue
and black dress
from Traina-
Norell, c. 1946

GLORIA GUINNESS

"Gloria Guinness is a classic example of a woman who knows what money can do — and she does it with grace." Time Magazine

A woman's duty, Gloria Guinness once remarked, was to satisfy men, not female fashion editors. Whether she lived up to her own standards is questionable. The Mexican-born socialite did indeed marry four times—but she was also a freelance contributor to fashion magazine *Harper's Bazaar*. And above all, of Truman Capote's four "swans" she was the one to whom her reputation as one of the best-dressed women meant the most.

"Gloria rarely takes any designer's ideas without insisting on changes." Time Magazine

According to one anecdote, Guinness always gave her close friend (and fashion rival) Babe Paley precise instructions on what she needed to pack for their annual yachting excursion. One year, the list stipulated only casual clothing and no jewelry—after all, the point of the journey was casual relaxation on the yacht. But on the first evening aboard, Guinness appeared on deck elegantly styled and "bedecked" with priceless diamonds. Not without reason—she had arranged an invitation for a formal dinner on land. The following year, learning from bitter experience, Paley brought on board not only glamorous evening gowns but also a selection of her finest jewelry. And Gloria Guinness? She made sure that the party did not leave the yacht even once.

Guinness did not really need to indulge in such behavior to ensure her status as a style icon. Her terrific fashion sense would have been quite enough by itself. Despite or perhaps exactly because of her extravagant personality she preferred simple

elegance. Her favorite designers were Balenciaga and Givenchy, to whom she would give strict instructions during fittings—in the end, nothing was more important to her than a style she could call her own. She went so far as to create a complete wardrobe for every residence (five in all) in a style adapted to each city. Her Coco Chanel ensembles for example she wore exclusively in Lausanne, as in her opinion there were already too many women wearing them in New York and Paris. And when, thanks to her, Capri pants came into fashion in the U.S., she naturally refused to wear such "vulgar" items any more. What else could you expect of her?

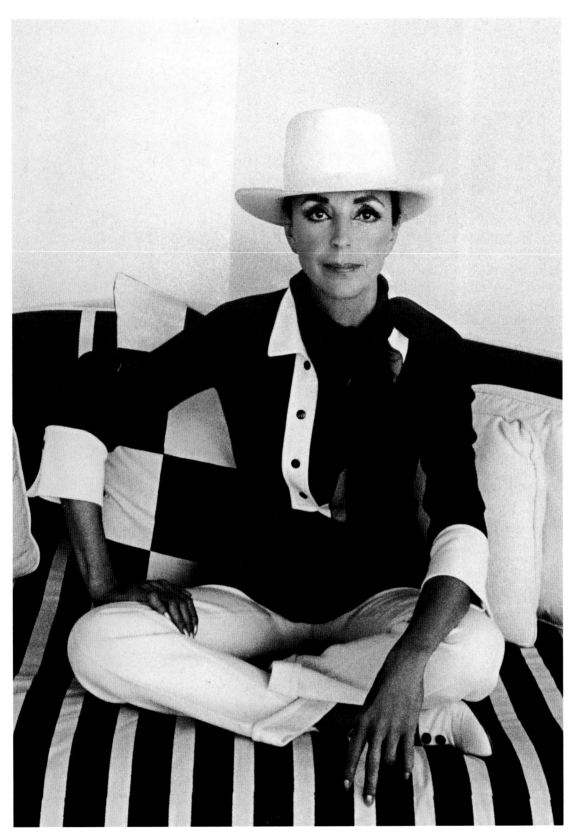

Gloria Guinness
in Mexico, 1970

*"It was about good looks, brains, taste, and style....
The only ingredient I brought to this recipe was the recognition that,
while you have to be natural, you also have to be different....
In my day, different meant not having your hair done in a pompadour
and adorning it with a snood, or not trying to hide your intelligence
behind a sea of frills. I somehow knew there was a glut in that market.
I opted for a scrubbed-clean, polished look. I thought it was more
important to have an intelligence that showed, a humor that never
failed, and a healthy interest in men."*

SLIM KEITH

Nancy "Slim" Gross Hawks Hayward Keith wanted nothing more than to lead an exciting, carefree life. However, neither born rich nor having professional ambitions, only one way remained available to her to attain the lifestyle she fancied, the old-fashioned way—marrying money. For Slim, that was an easy enough goal. She saw herself as the perfect jewel on the arm of an influential man. She was tall, slim, and extraordinarily pretty. And what's more, she had personality, wit, and charm. And the most important, as she discovered, was a requisite interest in men—and the necessary intelligence to adapt to the given environment of her partner.

Looking back at her life (which includes three highly lucrative marriages, with a Hollywood director, a Broadway producer, and an English aristocrat), one quality stands out— her style, which over the years lost nothing of its modernity. Although she had a weakness for luxury, her exquisite taste in clothing gave her an air distinct from the prevailing Hollywood glamour. As far as her appearance was concerned, she was an individualist: she preferred to look freshly radiant with a healthy tan; indeed, you might say squeaky clean. At a time when women in high society depended mainly on large wardrobes, the "California girl" preferred her hair simply styled (commonly with a simple pony tail and a middle part) and clothes that gave her a sporty, natural look but that were nonetheless conspicuously chic and sexy.

Of the four "swan" socialites singled out by writer Truman Capote, Slim Keith was the one whose style has had the most influence on modern fashion. What she considered as basic wardrobe is these days the quintessence of sporty elegance. Her legacy is thus not her wealth but her look, which is still fashionable today.

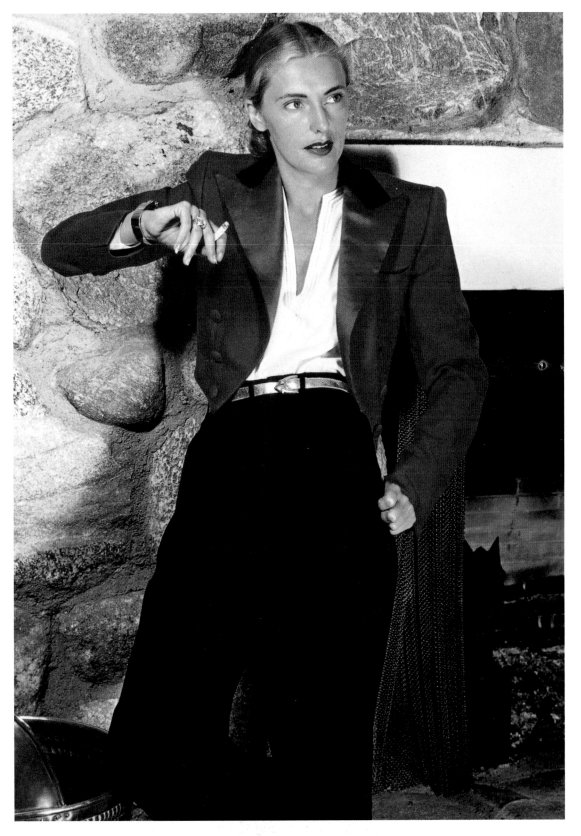

Slim Keith posing with her dog Meatball and wearing Claire McCardell, undated

At home in an outfit she designed herself, 1945

C. Z. GUEST

"It's important not to have too many clothes. Keep it simple. There's only so much you can wear."

C. Z. Guest was a real American lady—but never thought of behaving like one. Born the daughter of an extremely rich, old-family Boston investment banker, she enjoyed life to the fullest. At nineteen, she appeared as a showgirl on Broadway, and from there, out of boredom, went on to Hollywood. She remained only a few months; after a short stint as an actress and a number of mentions in the gossip columns, she moved on to Mexico, where she had herself painted in the nude (a scandalous thing to do in the forties) by socialist artist and womanizer Diego Rivera. And then she went on to Havana, to marry completely out of her class, with Ernest Hemingway as a witness. But there was one thing she faithfully stuck to her whole life—her style.

In later years, she made her name mainly with her formal social events, riding successes, and spectacular gardens—her gardening column was syndicated in 350 newspapers. But C. Z. (as she was known) had precise ideas how to dress. She considered women in trousers an abomination (she only wore them for sport and hunting), trends something to ignore (she mainly took care to choose tailoring that flattered her physique), and French fashion for the most part much too complicated (with the exception of Balenciaga and Givenchy, whom she often favored, along with American designer Mainbocher). Tall and ash blonde, she preferred a sporty, elegant Palm Beach style that was defined by heavy fabrics, clear cut lines, and delicate pastel shades. Her appearance on an official occasion in a skirt and a large but thoroughly elegant knitted pullover was initially taken as an insult in American high society—only later to be copied a dozen times over.

When C. Z. Guest, whose real name was Lucy, died in her eighties, she was still popular, well to do, beautiful, and immaculately dressed. As *Time* magazine wrote, in an issue in which she featured on the cover, she was "a legend even in her lifetime."

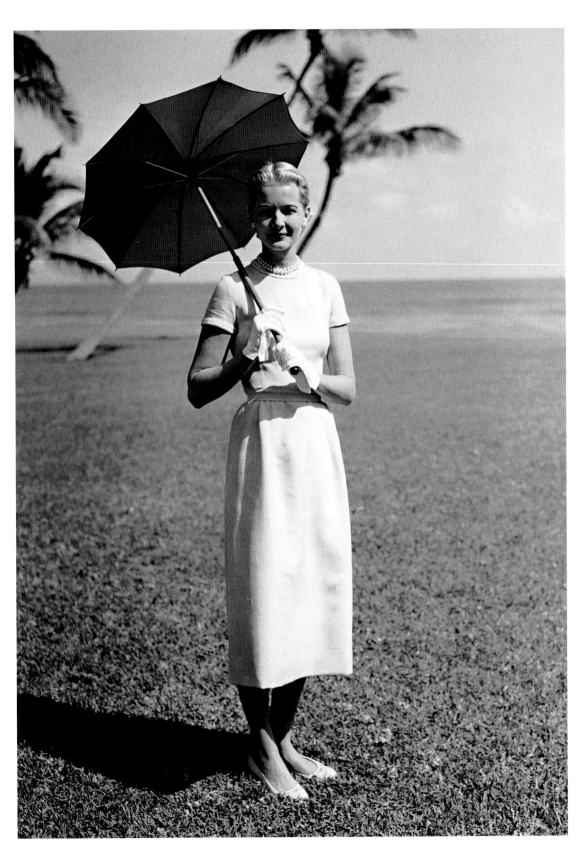

C. Z. Guest poses with an umbrella, Palm Beach, 1954

\>\>
Wearing a floral dress with a short-sleeve La Galerie jacket by Mainbocher, 1950; and standing at the Grecian temple pool of her oceanfront estate, Villa Artemis, Palm Beach, 1962

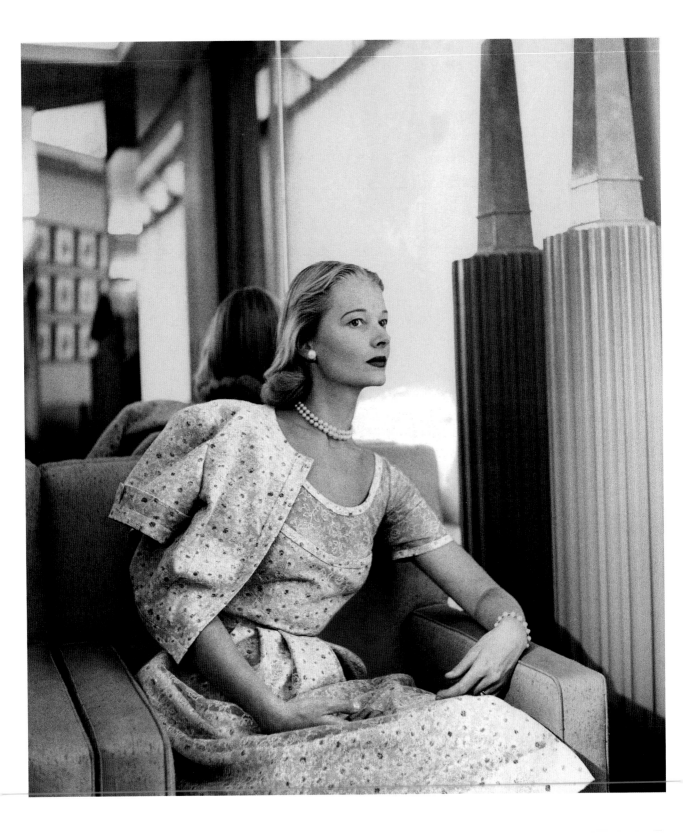

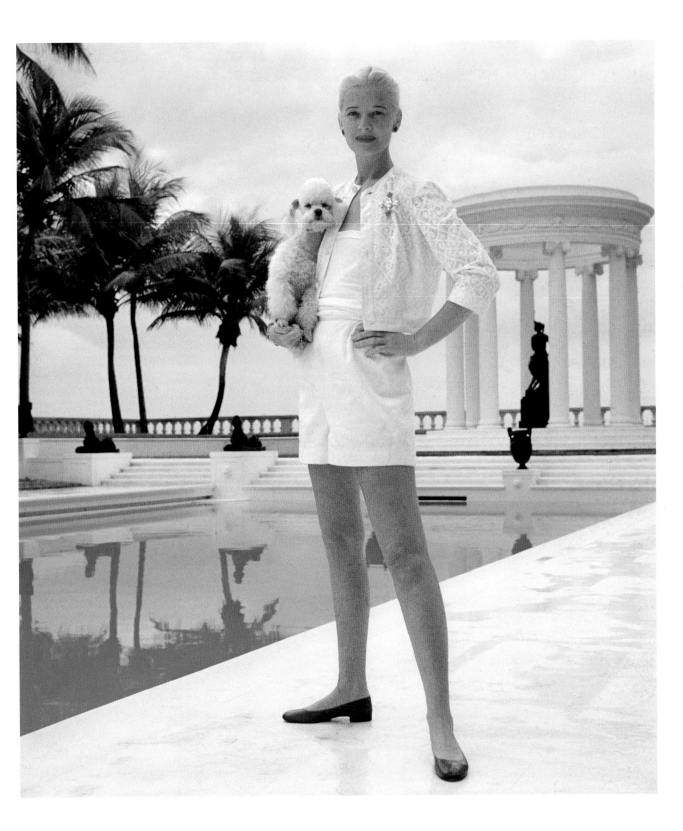

CAROLINA HERRERA

"Herrera's clothing mirrors the designer's own sophistication and class, and puts a modern spin on Old World charm." New York Magazine

True elegance is not something you can learn overnight. Carolina Herrera is firmly convinced you are born elegant. The best example of her theory is the fashion designer herself. María Carolina Josefina Pacanins y Niño, as she was born in 1939, was the daughter of an old landowning family in Venezuela who learned as a child what it took to be accepted by the South American upper classes: a strong dash of style and the aforementioned elegance.

Herrera discovered her love of haute couture early on. She went to her first fashion show (Balenciaga in Paris with her grandmother) at thirteen, and at fifteen had her first designer dress (a gown by Lanvin). Later, in the seventies, she ultimately conquered New York wearing the designs of Giorgio Armani, Valentino, and French couturiers Emanuel Ungaro and Yves Saint Laurent, even making it onto the International Best-Dressed list. Andy Warhol painted her portrait, Robert Mapplethorpe photographed her on Mustique, and Jackie Onassis made Herrera her personal style adviser for the last twelve years of her life. Admittedly, it took Diana Vreeland to turn the fashion icon Herrera into a fashion designer. The editor-in-chief of American *Vogue* encouraged Herrera to present her first self-designed collection. Which she did.

Her couture collection appeared in 1981, three years later came the first fur collection, followed in 1986 by her affordable CH line. After designing the

bridal gown for Caroline Kennedy in 1987, she immediately brought out a complete bridal collection, which was followed by ranges of scents, jewelry, and accessories. The designs all bear the designer's signature—they are feminine, contemporary, cosmopolitan, and of course extremely elegant.

Carolina Herrera never went to a fashion school in her life. Self-taught, she owes her sure sense of classic elegance to her origins— but her intuitive style is all her doing. And that is indeed something one cannot learn.

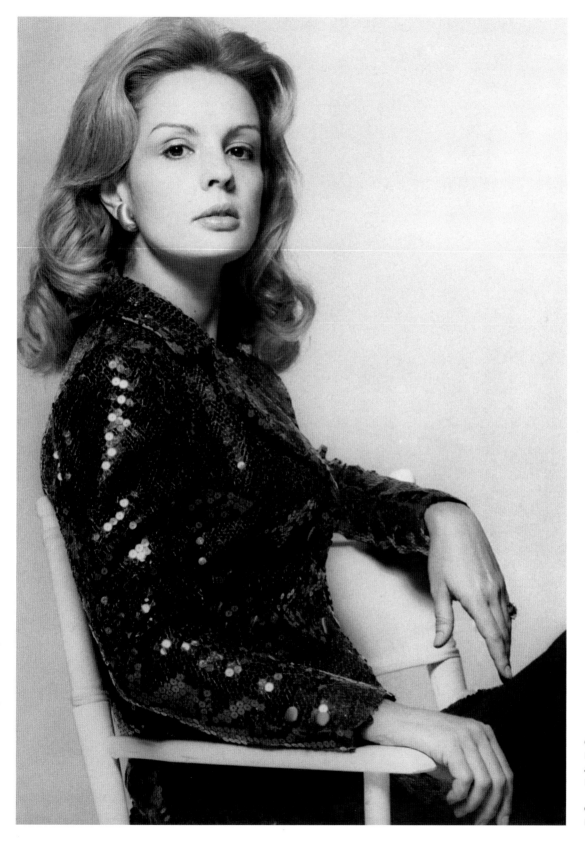

Carolina
Herrera at
a party,
New York, 2003

Carolina
Herrera, 1974

THE IT

Edie Sedgwick
Chloë Sevigny
Louise Brooks
Bianca Jagger
Sienna Miller
Marchesa Luisa Casati
Twiggy
Kate Moss
Mary Quant

GIRLS

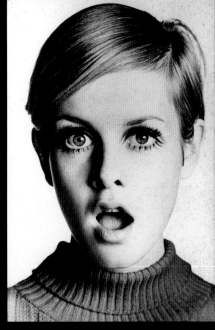
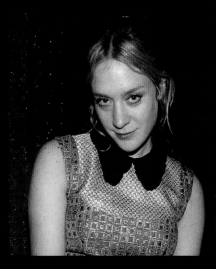
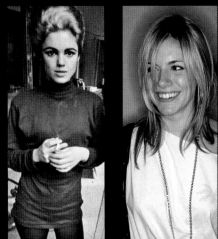
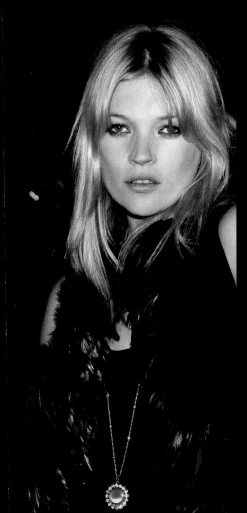
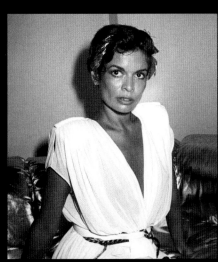
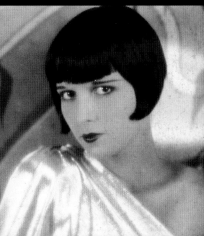

EDIE SEDGWICK

"She created her own identity. She may only have had fifteen minutes of fame, but her style and image influenced a whole generation." John Galliano

No It girl was the girl of the moment the way she was—Edie Sedgwick, the smart American party girl who was transformed by Andy Warhol into an icon, who lost her way in the big city, who was put by Diana Vreeland on the cover of *Vogue*, who took drugs, and who in the end induced her own downfall. Yet she is remembered for one thing above all—her appearance.

Born Edith Minturn Sedgwick, a millionaire's daughter from a rather volatile home, by the age of twenty Edie had abandoned her studies at Harvard and had had a long stay in a mental hospital. In New York, she ultimately met Andy Warhol, who immediately introduced her to the artsy clique at The Factory. Warhol was fascinated by her look, which she honed to perfection under his expert guidance. Inspired by her new avant-garde surroundings, Edie swapped her long natural brunette hair for bleached, pixie-cut ash blonde. She emphasized her eyes with heavy eyeliner, dark accentuated eyebrows, and extra-thick false eyelashes. Her outfits were often composed of striped T-shirts, a short mink or leopard fur coat, opaque black leotards, ultra-high heels, and a pair of antique earrings, the largest she could find. Sedgwick rarely varied her outfits—but it was precisely this clearly defined wardrobe that made her one of the founders of the popular sixties beatnik look.

With Warhol she made a number of semi-documentary art films (one bears the strikingly apt title *Poor Little Rich Girl*), tried LSD, and became part of the New York scene. But when Warhol unexpectedly dropped Sedgwick after a year or so and pushed her out of The Factory, it was downhill all the way for the party girl. Her father refused her access to her accounts, and she turned increasingly to drugs, finally dying of an overdose of barbiturates. She was just twenty-eight years old.

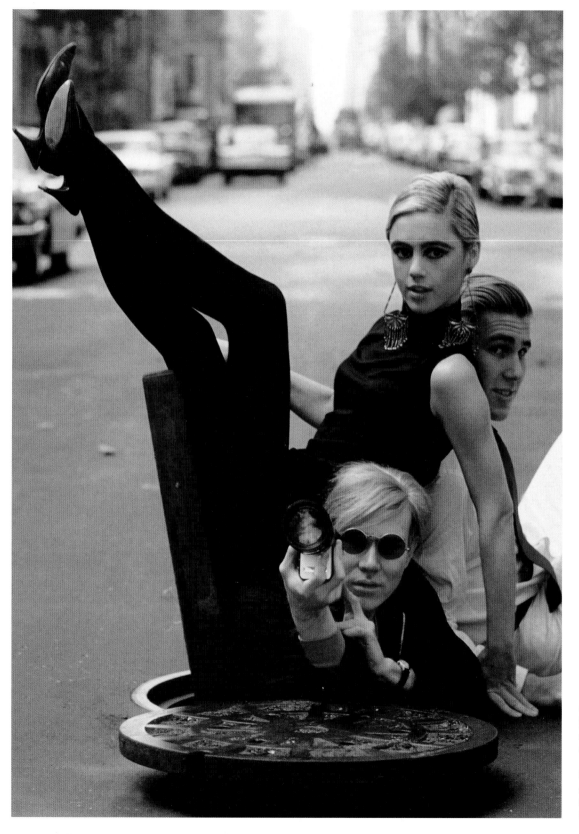

Edie Sedgwick
during the
filming of
Andy Warhol's
Kitchen, 1965

Sedgwick with
Andy Warhol
and Chuck Wein,
New York, 1965

CHLOË SEVIGNY

"I was very into dress-up as a child, and I had trunks of old costumes my mother would get for me at thrift shops—gowns and heels and stuff. It's just instinctual for me."

"I'm very average, you know, very plain-Jane. Very all-American. So I think I try to play it off by looking like a crazy East European girl. By wearing an insane outfit, I don't think I'm so boring and normal."

Downtown New York had been waiting for a girl like Chloë Sevigny. That's because no one more perfectly embodied what makes the city go—an uncompromising balancing act between glamour and trash, sex and smugness, intellect and creativity.

Reared in a wealthy environment in conservative small-town Connecticut, Sevigny left home in the early nineties and settled in Brooklyn. Her favorite activity as an eighteen-year-old was watching skateboarders in Tompkins Square Park. It was only a passing phase, and she herself was discovered several times—to work as a fashion magazine assistant, as an actress in the indie film *Kids*, and ultimately as a muse for a whole city. Shortly before her breakthrough as an actress, *The New Yorker* called her "the coolest girl in the world." Without having a goal, the flaxen-haired girl with the light blue bedroom eyes had arrived.

Just as effortless as the launch of her career is her style. Sevigny's capacity to throw together apparently any old clothes to make up an outfit is legendary—and difficult to copy. That's because the actress has the courage to take risks, and wears nonconformist vintage and designer combinations that suit only her. Her priority is not to be beautiful, but to be interesting. Even in haute couture, which she sometimes wears to premieres, she is always still Chloë—surprising and contradictory.

After over ten years in show business, Sevigny is the darling of independent film, having acted in more than twenty indie productions. In her choice of roles she is just as consistent as she is with her outfits—anything but mainstream, playing provocative personalities in extreme situations. In fact, always a bit different from everyone else. And yet always herself—regardless of whether it's in New York or anywhere else.

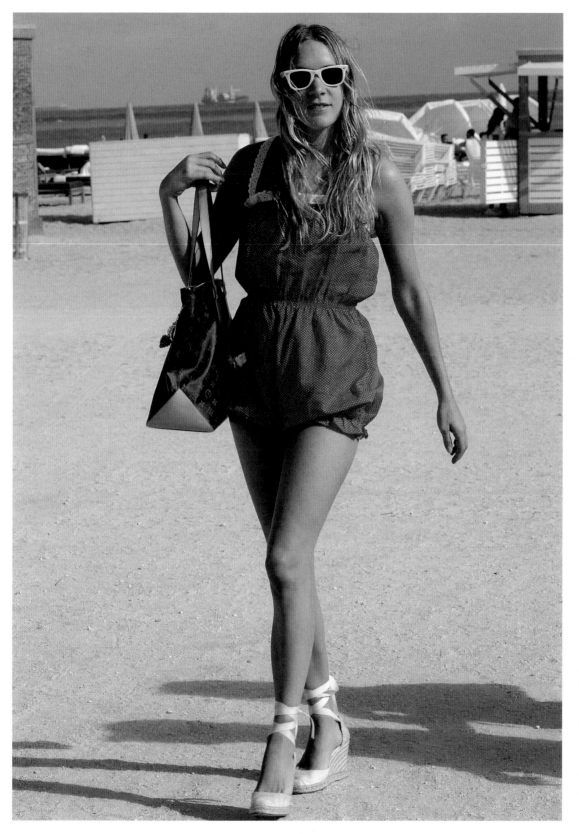

Chloë Sevigny
arrives at the FIT
Annual Couture
Council Award
for Artistry of
Fashion, New
York, 2007

Strolling on the
beach in a signal
red playsuit,
Florida, 2004

LOUISE BROOKS

"When I went to Hollywood in 1927, the girls were wearing lumpy sweaters and skirts … I was wearing sleek suits and half naked beaded gowns and piles and piles of furs."

Louise Brooks was not a girl to hold back. She took what tickled her fancy and left what didn't. She had numerous affairs, none of them long-lasting. In short, Louise Brooks, American silent film star of the 1920s, was a cocky chick—self-confident, independent, the prototypical flapper. And even if her list of films is short, the flapper style she helped create is all the more legendary for it.

The most conspicuous thing about Brooks was probably her haircut, a boyish bob whose gleaming coal-black tips rested gently on her cheekbones. She had a kiss-proof cosmetic smile that was so radiant you could recognize it even in the darkest jazz clubs, and heavily accentuated, widely spaced eyes, the gleam in which not even the blue smoke from the cigarette in the obligatory holder could conceal.

"A well dressed woman, even though her purse is painfully empty, can conquer the world."

Instead of the corsets typical of her day, Brooks wore modern underwear to feel more comfortable doing the Charleston, the Bunny Hug, or a shimmy. Her bras were designed to flatten her breasts, wholly in the spirit of an age that preferred youthful vigor to generous cleavage. She wore a cloche—a round, brimless hat—on her head, while on her body she wore long necklaces and plain loose dresses with a hipster waistline. Her arms were bare; her legs covered in rayon stockings fastened to a garter belt. Scandalously, her dresses barely reached below the knees, which occasionally flitted into view (for this reason Louise Brooks went so far as to "make-up" her knees with powder and rouge).

Despite her talent, conservative Hollywood soon punished the actress for her fast living and ignored her when casting films. The flapper style didn't last very long either—in the crisis-stricken thirties, there was simply no room for hedonism and intemperate celebration.

Even though their time was all too short, flappers formed the first really modern women's movement. And that is precisely why Louise Brooks, who after a brief period of greatness died poor and alone, has not been forgotten.

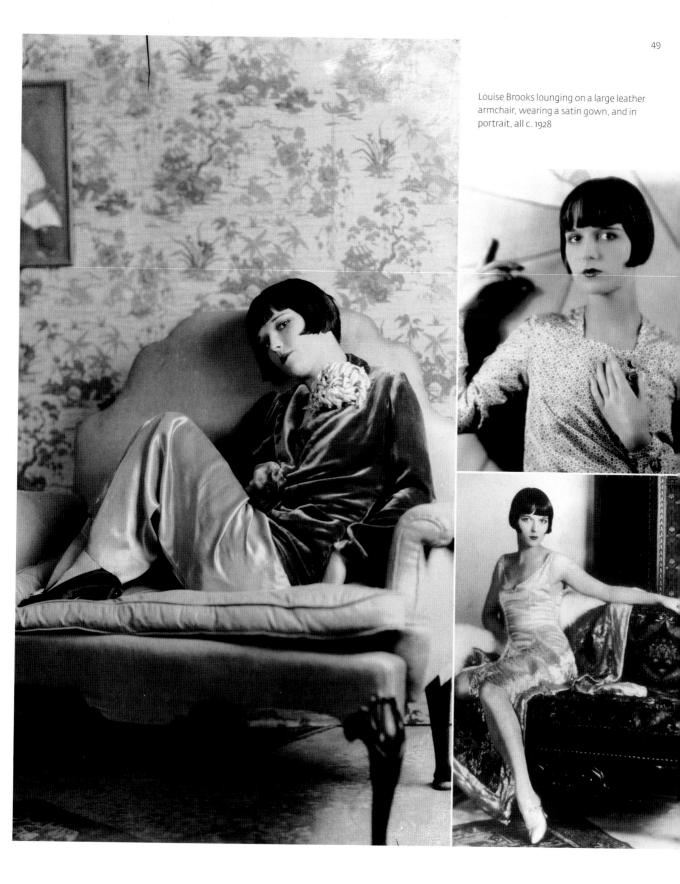

Louise Brooks lounging on a large leather armchair, wearing a satin gown, and in portrait, all c. 1928

BIANCA JAGGER

"I was very scared of being sexy, attractive and voluptuous."

New York, 1977: Studio 54 was the coolest disco in town, if not the most fashionable pleasuredome in the world. The door policy, often enforced personally by owner Steve Rubell, was arbitrary and fairly rigorous. Being a celebrity was no guarantee of entry, though unusual clothing was a bonus, even for unknowns. But a select few always got in. Prominent among them was Bianca Jagger, fashion model, rock star wife, eccentric party girl, and one thing above all—global fashion model for the disco generation.

Yet her first grand fashion moment was anything but planned. In May 1971, the Nicaraguan-born model married rock star Mick Jagger amidst a hail of flashbulbs in a fishermen's chapel near St. Tropez. At least as exciting as her husband was her outfit, a figure-hugging tailored white pantsuit by Yves Saint Laurent, combined with a broad-rimmed cloche hat, likewise by YSL. The only thing missing was the blouse below the suit.

The fashion world was initially shocked, then entranced. Today, Bianca Jagger insists that it wasn't a deliberate fashion statement—she happened to be four months' pregnant. The suit had been made at the start of the pregnancy, and by the time of the wedding the blouse was already too small. But in the period that followed, what with film premieres, photo shoots, and the VIP area of Studio 54, Jagger proved more than adequately that she had the looks to be a disco queen. She might wear a Halston fur at midday, and high-heel it through the nightspots on Manolo Blahniks. The high point of her career as Madame Jet Set was her birthday appearance, once again at Studio 54. Led by a superbly fit young man, Bianca rode a white horse through the club. She was wearing a dress by Halston, he nothing more than a mere dusting of gold. In the eighties, after her divorce from Mick Jagger, Bianca left the dance floor. The disco girl became a committed human rights activist.

"Style is knowing what suits you, who you are and what are your assets. It is also accepting it all. Accentuate the assets and make of the flaws assets."

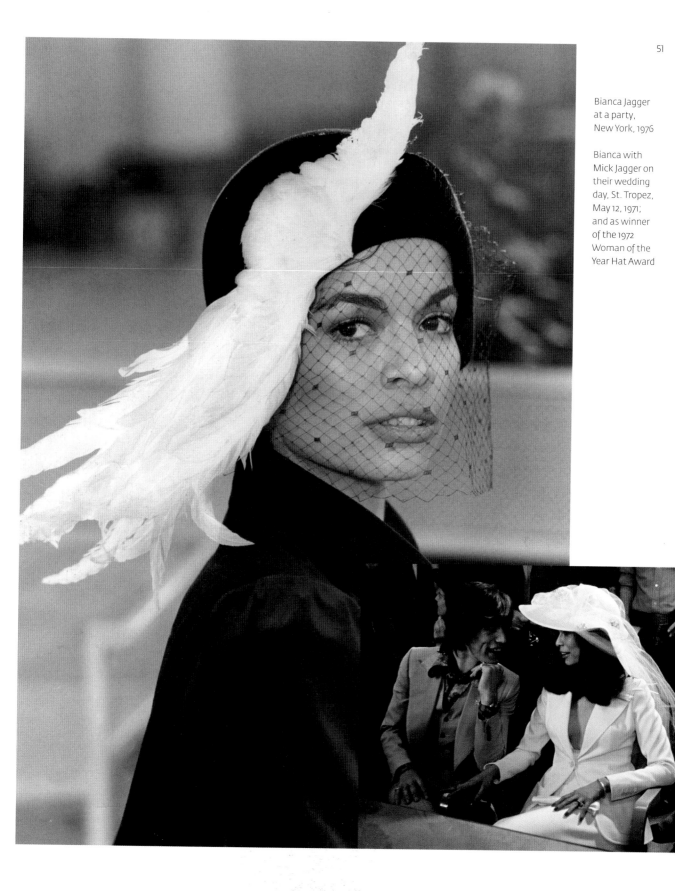

Bianca Jagger
at a party,
New York, 1976

Bianca with
Mick Jagger on
their wedding
day, St. Tropez,
May 12, 1971;
and as winner
of the 1972
Woman of the
Year Hat Award

SIENNA MILLER

"Style is a combination of opportunity, time, place, body and mood. You can't buy style, you can only gradually learn it."

Sometimes it takes only a single girl for the whole world to fall in love—in love with a look that is. There's no other way of explaining the to-do about Sienna Miller. She is after all just an actress. But it's her style that has made her famous. Not only imitated a million times over, but so idiosyncratic that it has acquired a name of its own—boho chic.

Boho is short for "bohemian," and that's just how the New York-born English girl looks. Her style is a little bit folklore and a little bit hippie—but above all rather individual. Her mix-and-match combinations of vintage and designer pieces, normally with an eye-catching, casually placed accessory, look both cool and carefree. Sienna Miller wears crumpled suede pirate boots with schoolgirl skirts, loose lace dresses on top of drainpipe jeans, and XXL slouch hats with colorfully patterned Ossie Clark tops. Always experimenting, she combines soft baggy shirts with broad, coin-studded belts, short feminine dresses with heavy cowboy boots, and heavy chains with delicate silk blouses. Surprisingly, only with her hair and makeup is the blue-eyed blond surprisingly conservative—but there

she's "far too unassuming." In general, Sienna Miller is rather uncomfortable with her reputation as a fashion icon. She thinks it's crazy for her look to have a label and be declared a global trend. In fact, with her outfits being copied around the world, Sienna Miller is through with her look. For her, boho chic is over, finished, ancient history.

Whether it will take its summary dismissal lying down is another matter. Because love affairs can't be broken off unilaterally so easily.

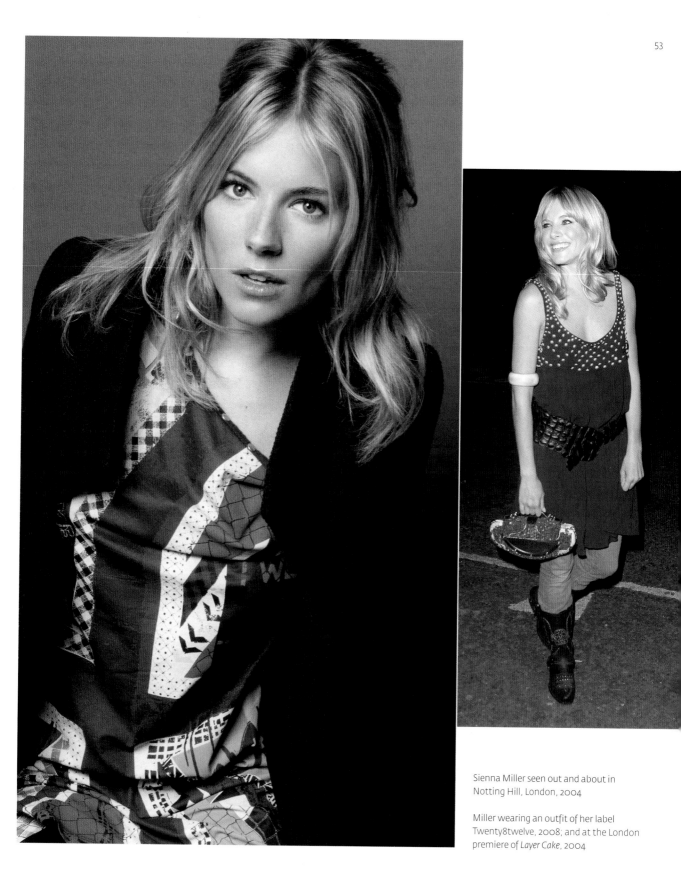

Sienna Miller seen out and about in
Notting Hill, London, 2004

Miller wearing an outfit of her label
Twenty8twelve, 2008; and at the London
premiere of *Layer Cake*, 2004

MARCHESA LUISA CASATI

"The 20th-century Italian aristocrat Marchesa Luisa Casati is the godmother of the new eccentricity movement."

The life of Luisa Casati was one long, magnificent performance—never sensible in the conventional sense, but making up for it in extravagance. Spoiled muse, bizarre artistic personality, female dandy—the Marchesa was all of these. Inheriting at a young age one of the largest fortunes in Italy, she was the quintessential It girl, even if such a term didn't exist in the early twentieth century.

Casati was not remarkably pretty let alone beautiful, but extraordinarily tall and thin. The immensely rich playgirl's most striking feature was her huge green eyes—radiant and almond-shaped, their bearer was predestined to have an intense gaze. And the marchesa knew how to accentuate them. With bobbed hair dyed fiery red and a face powdered white, her eyes—generally lined in deep black—seemed even more threatening.

Her fantastic gowns, more costumes than clothing, were commissioned from Poiret, Fortuny, and Erté. She garnered as much attention with her constant companions: two tamed cheetahs wearing diamond-studded collars, a servant covered in gold leaf, and a boa constrictor doubling as a shawl during her travels. All her life Casati was eccentric, glamorous, and extravagant—under no circumstances rational.

She gave masked balls in Venice, Capri, and Paris that cost a fortune in the real sense of the word. However, her greatest legacy was art—even if not her own. Casati had an eye for talent, and became a liberal patron of countless now important artists and writers. A reward for her narcissism—hardly anyone has been the subject of more portraits than she.

Casati died in poverty in 1957, an exile in London. She was buried with her stuffed Pekinese at her feet and a quote from Shakespeare on her tomb: "Age cannot wither her, nor custom stale / Her infinite variety." It would have surely pleased her.

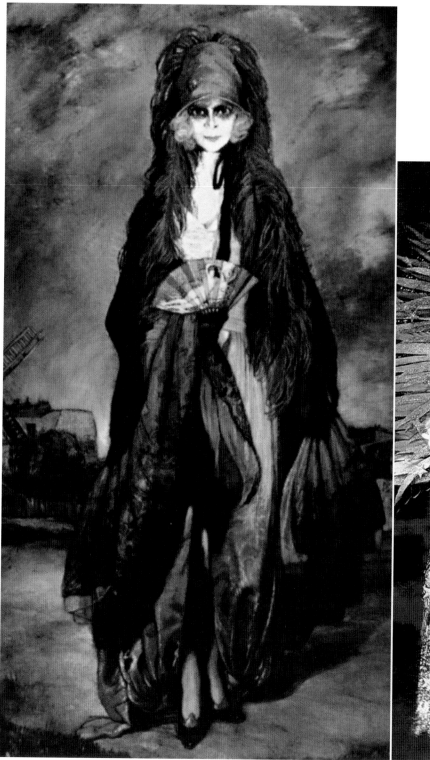

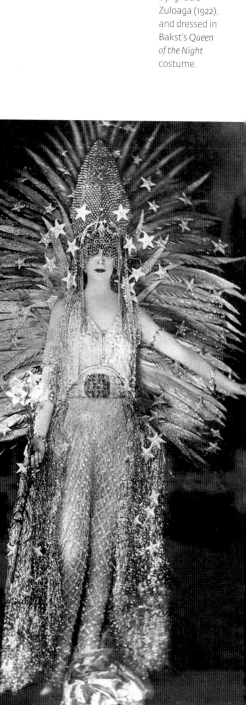

The Marchesa Casati, painting by Ignacio Zuloaga (1922), and dressed in Bakst's *Queen of the Night* costume.

TWIGGY

"It's not what you'd call a figure, is it?"

What did it take to sweep away the bulky adult fashions of the fifties? Not much. More precisely, just a spindly middle-class girl from Neasden, England called Lesley Hornby, better known to the world as Twiggy.

In 1964, fifteen-year-old Lesley became a hairdresser's model for Vidal Sassoon, at the time the most sought-after coiffeur in London. She was given a blonde bob, photographed, ended up on the cover of a magazine—and rocketed straight into the sky. Schoolgirl Lesley became Twiggy, the world's first supermodel. In fashion, which is easy to inspire but difficult to change, all of a sudden nothing was the same. Twiggy was in the right place at the right time, and had everything it took to spark a revolution. With her 30-22-31 figure, childlike features, and gawky limbs, Twiggy was the antithesis of the voluptuous ideal of beauty in the 1950s. What's more, she lacked that must-have quality for any model then—elegance. The archetypal dolly bird, Twiggy was dainty but not delicate. She danced across the catwalk as light as a feather, and posed for fashion photographers with knees bent and an ingenuous air.

The childish proportions of her figure went perfectly with the new mod look, which she came to embody. Thanks to Mary Quant, hemlines rose and silhouettes stretched, first in Swinging London and eventually worldwide. Schoolgirl dresses and straight shifts were worn with tights, flat boots, or Mary Janes; low-slung hipsters combined with close-fitting ribbed pullovers. Twiggy never saw herself as part of a movement, much less as part of the international fashion jet set. By the age of nineteen, the "most expensive beanpole in the world" had had enough of modeling and gave it up. Her career as a fashion model had lasted less than five years—but that was enough to become the legend of an entire generation.

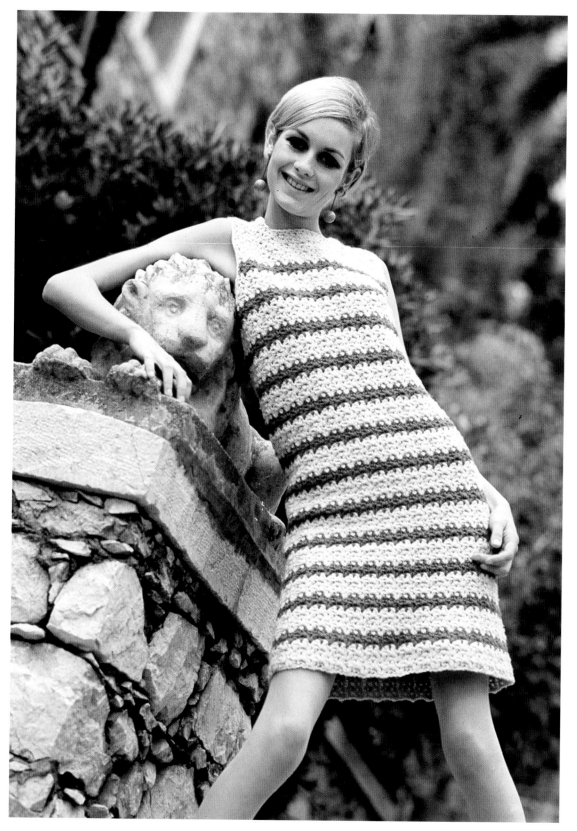

Twiggy wearing a fashionable dress while posing with her arm around a stone lion, 1967

>>
Twiggy on the beach, and wearing a hooded mini-dress, London, both 1967

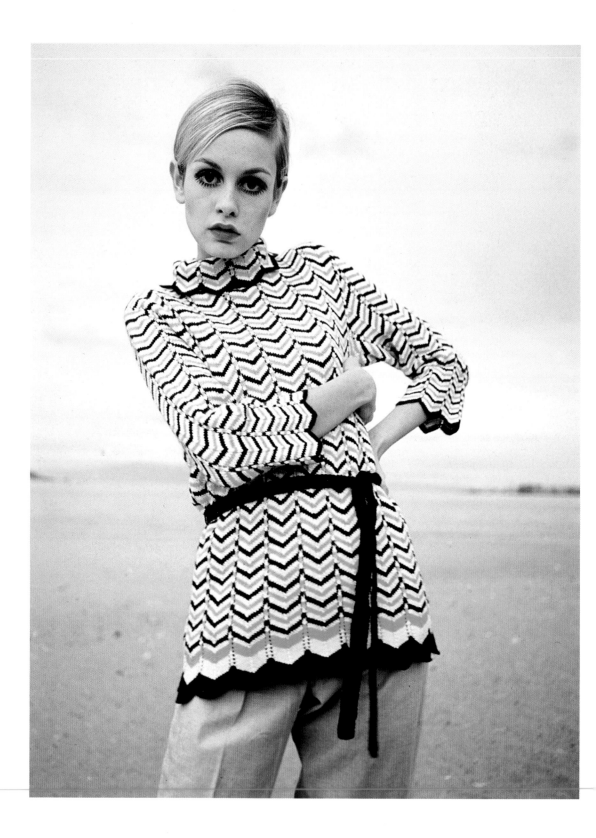

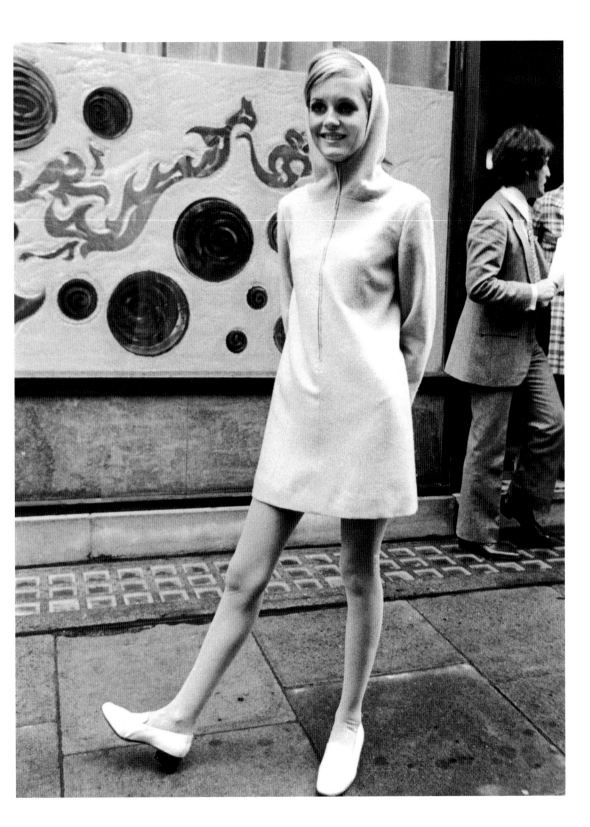

KATE MOSS

"Kate has always been the heartbeat of fashion. She lives it as much as she embodies it, so it's no major surprise at her following." John Galliano

Kate Moss is no ordinary supermodel. Lacking curves and barely above medium height, properly speaking she ought not to be one at all. Nonetheless, she sells more fashion than any of her colleagues. How does she do it? It's all down to herself and the way she wears clothes.

She was discovered at the age of 14 at JFK airport in New York in 1988. Two years later, she brought off what nobody had achieved since Twiggy in the 60s – fashion abandoned its old ideals. Authentic, pure, and in a terribly vulnerable way sexy, Moss embodied an image of woman uncompromisingly coming to terms with reality. It was a novelty in the world of fashion.

It was no wonder that in the nineties Kate Moss soon became the face of the newly emerging grunge – and a decade later that of a whole generation. With the arrival of the new millennium, she has managed to shake off the labels. And despite or perhaps because of her turbulent private life, she has risen to become the ultimate icon of style. And yet she never looks as if she spends hours in front of the closet. In fact, she effortlessly combines what she feels like – short waistcoats and skinny jeans, vintage pieces with high fashion,

pirate boots with a parka, hot pants with pumps. Plus occasional accessories, but never in the "safe choice" category and yet somehow looking effortlessly a natural part of the outfit. The result of these combinations is an anti-designer look with a touch of rock-star glamour that is copied worldwide as soon as Moss leaves the front door. Kate Moss's life is not unblemished, any more than her look. But she's never apologized for it. Nor does she need to, because that's what makes her the perfect muse of her time.

"Kate is someone with energy, passion, sophistication, and cool. If you put those things together, you have taste." Donna Karan

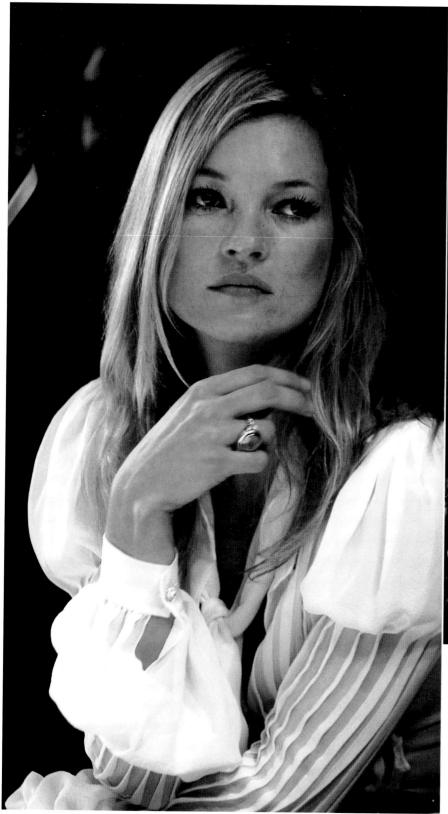

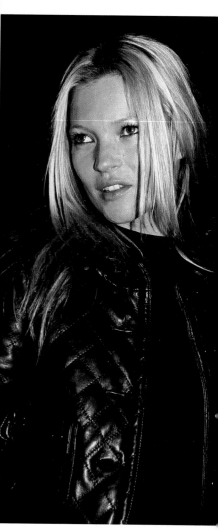

Kate Moss seen in London, 2006

Kate Moss attends Milan Fashion Week,
2006, and London Fashion Week, 2007

MARY QUANT

"Clothes should be fun."

It was a very small skirt that made a super big splash. When London started to swing in the early sixties, it was Mary Quant whose style perfectly captured the era's mood. Her look: light-hearted, androgynous, and rather provocative.

Bored with the teen fashions of the fifties, the art school graduate with the geometrically cropped hairstyle made her own clothes. She dispensed with frills, wasp waists, and petticoats. Instead she preferred to combine colorful tights with short shift dresses that emphasized neither breasts nor waists. Like Coco Chanel thirty years earlier, she made clothes that did not restrict a woman's freedom of movement. And yet she was completely different.

Very soon the nonchalant Londoner was selling her fashions. She designed closefitting knitted dresses, bags with long straps, and colorful PVC coats—a material that up to then had only been used for table-cloths and floors. And then there was the Skirt, which was far too short not to get tradition-conscious guardians of morality manning the barricades. At a time when thumbing your nose at the establishment mattered, it was a breakthrough. Quant, who only wanted to have fun with fashion, actually revolution-ized it. The miniskirt became the symbol of an entire generation.

But Mary Quant not only knew how to start a revolution. She also knew how to become a legend—by stopping at the right moment. With the onset of the Age of Aquarius, the designer turned to new projects. She did not go along with the radical change that was the antithesis of her own. The outcome was the conserva-tion of a clearly defined style, a style preserved by later designers. To this day, baby dolls, hot pants, and miniskirts periodically make an appearance on the catwalk. Though Mary Quant's skirts were ultra short, their influence has been much longer lived. And there is no end in sight.

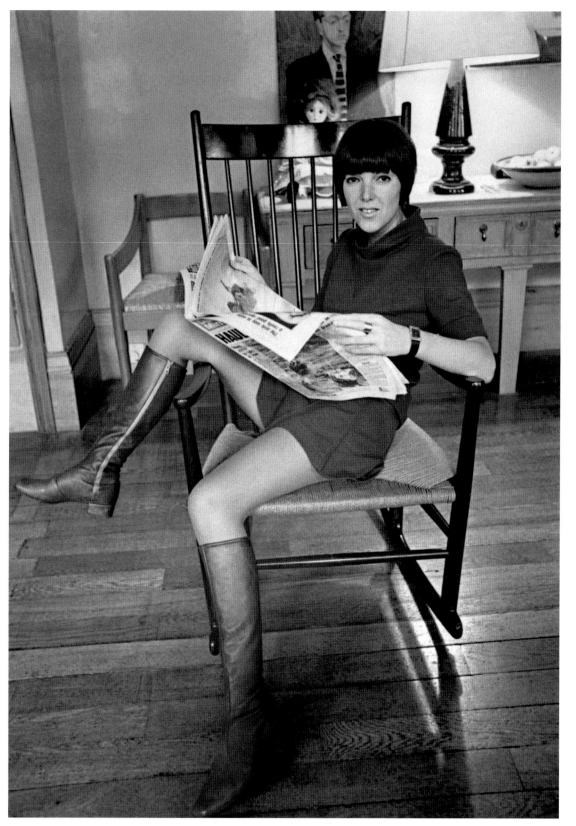

Mary Quant,
1965

Wearing a
miniskirt, 1967

THE BOM

Marilyn Monroe
Brigitte Bardot
Gwen Stefani

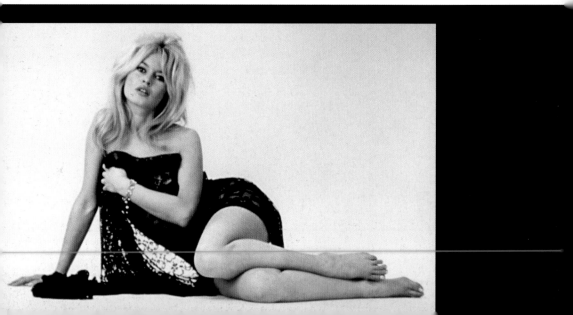

BSHELLS

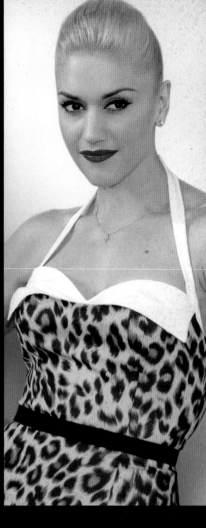

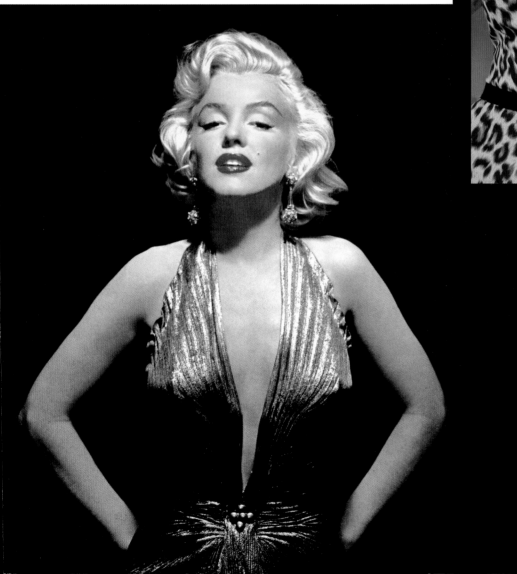

MARILYN MONROE

*"The body is meant
to be seen,
not all covered up."*

*"Marilyn is a kind of ultimate. She is uniquely feminine. Everything she does is different,
strange, and exciting, from the way she talks to the way she uses that magnificent torso.
She makes a man proud to be a man." Clark Gable*

Nobody embodied the image of the Hollywood screen goddess as she did—Marilyn Monroe, the most legendary blond, born Norma Jeane Baker as a brunette and raised in countless foster homes in California. Her secret was blatant, in-your-face sex. Her reputation as a sex symbol, the attractive but dumb blond conquering the world with naïve charm and eating men alive, was just the role for her. It was one she actually never really wanted to play, but which she handled to perfection.

As far as style was concerned, Marilyn Monroe was clear-eyed about what came across best. Actually, she never felt at ease in clothes—and if she had to wear them, it would only be for men. Monroe was convinced that the key to success was her well-shaped body, so the outfits she wore had only one purpose: to show off her body as if it was naked. Of course to do this there was no room for the demure style of the postwar era. In private, she favored to wear white terrycloth bathrobes. In public, she favored off-the-shoulder dresses, tight gowns with an hourglass silhouette, and above all low-cut halter dresses in endless variations—the legendary white dress in *The Seven Year Itch* is one version of it.

*"I don't mind making jokes, but I don't want
to look like one."*

Monroe not only liked clothing that emphasized and enlarged her cleavage, but also turned to another trick of the sex symbol, dispensing with underwear. Marilyn wanted her breasts to bounce and her nipples to peek erotically through, and she didn't want the sight of her derrière marred by panty lines. Seamstresses sewing her into her tight-fitting, zipper-less clothes before performances were instructed to follow the lines of her body and, above all, emphasize each buttock individually. She generally wore high heels, which had to be as bare as possible, and her jewelry was nearly always colorless diamonds. Nothing was to distract the eye from her body. Hair colored platinum blonde (the roots had to be touched up by an assistant every five days), glossy red lips, and a painted beauty spot highlighted the classic Monroe look, which until today has countless imitators.

Her appearance brought her little personal happiness. As a sex symbol, she was so successful that she could never show who she really was. Marilyn Monroe died at the age of thirty-six, ostensibly a suicide. What actually happened is still unclear, like so much in the life of Norma Jean Baker: the best-known blond in the world.

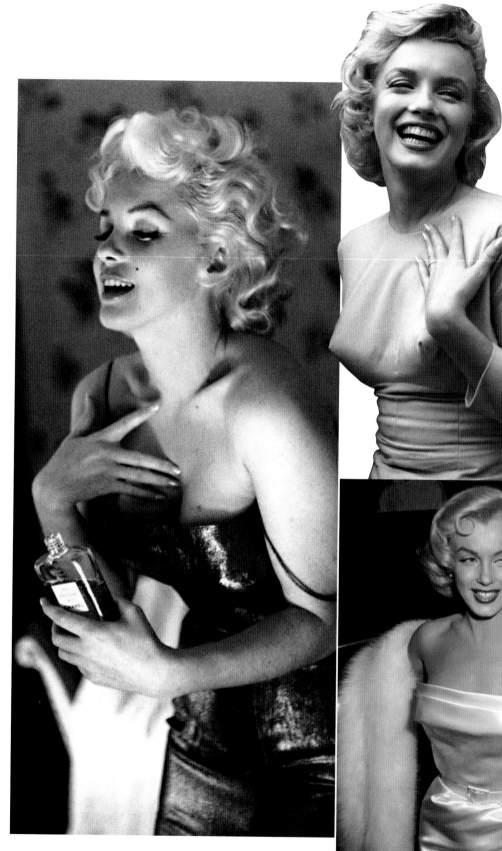

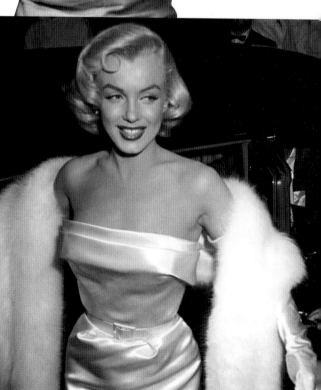

Marilyn Monroe poses for a portrait with her favorite perfume, Chanel No. 5, New York (left), 1955; arriving at a premiere (bottom), 1954; and outside her home at Englefield Green, 1956

>>
Marilyn Monroe, 1957

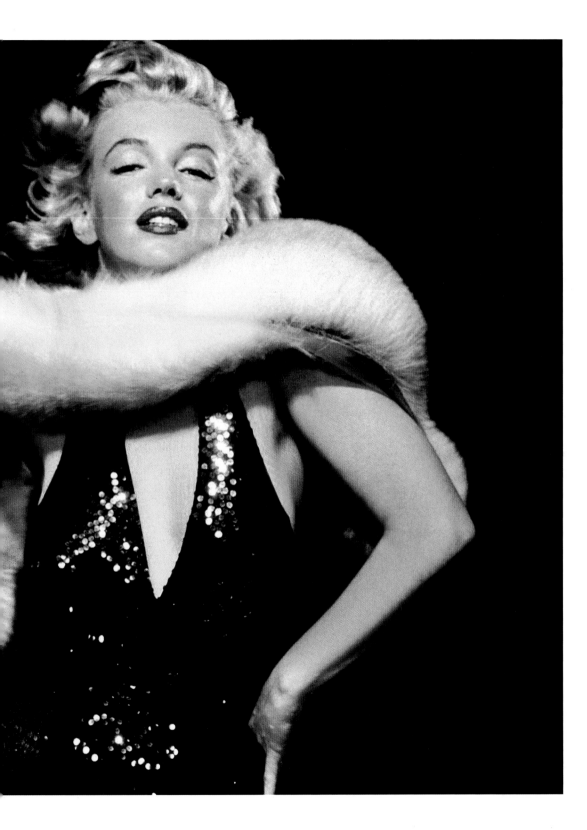

BRIGITTE BARDOT

"I've been very happy, very rich, very beautiful, much adulated, very famous, and very unhappy."

Brigitte Bardot didn't invent the busty blonde type—that was Marilyn Monroe some years earlier in the U. S. But the French actress was the first one to add a lighter, European flair to the taut image of the captivating sex bomb.

"I don't think when I make love."

Before her breakthrough, female stars floated across the red carpets of Cannes and Hollywood glamorously styled and apparently from another world. They were goddesses of the screen, unattainably beautiful to normal people. Instead BB, as she was called in her homeland, looked as if she spent all her time on the beach of St. Tropez, which to some extent she did. Her outfits—usually little, light cardigans, capris (often in Vichy check), wide belts worn on the hips, and flats—were a breath of fresh air, and conveyed a carefree casualness lacking in the early fifties. Her hair provided the missing sex appeal. Her long, combed-back, sandy-blonde hair cascaded casually behind her as if its owner had just gotten out of bed. At a time when hairspray was an indispensable item on every dressing table, she managed to establish naturalness (or at least a

staged version of it) as a fashion. BB was not just a myth and the greatest star France ever called its own. Brigitte Bardot represented above all a new kind of glamour, a hitherto unparalleled type of natural sexiness displayed with effortless ease: a new definition of beauty—nothing short of a revolution, in fact. By the way, at the height of her fame, Brigitte Bardot retired for good from the film industry.

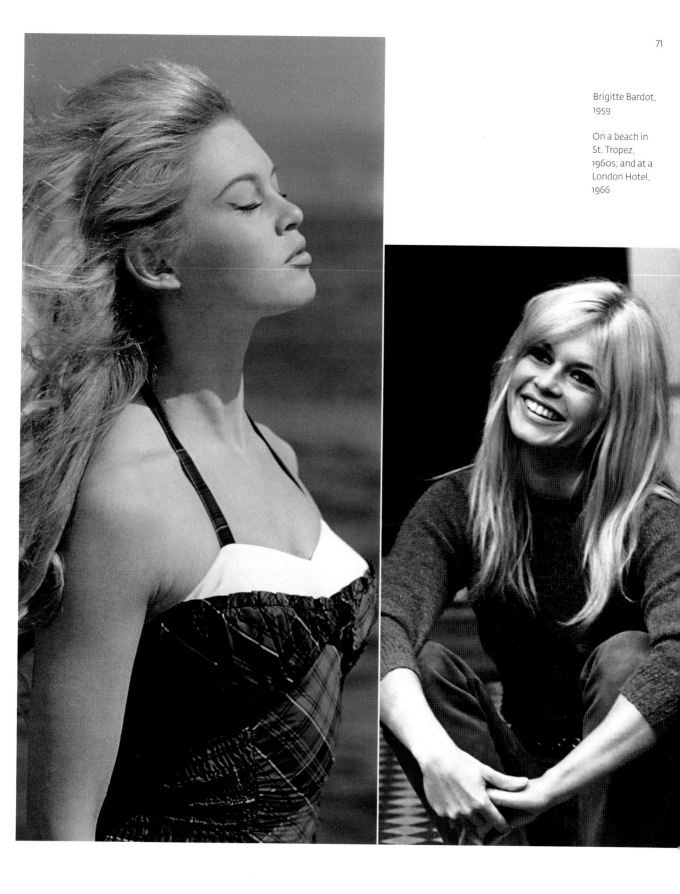

Brigitte Bardot,
1959

On a beach in
St. Tropez,
1960s; and at a
London Hotel,
1966

GWEN STEFANI

"Sometimes you have to sacrifice your performance for high heels."

Even icons of style underestimate themselves sometimes. Singer Gwen Stefani says she has absolutely no fashion sense. She simply wears what she likes. But the Californian singer is an absolute master of appearances. She constantly developed her look—from Californian skater girl to one of the most glamorous artist in the world of pop—without sacrificing her credibility.

While in the nineties her outfits were characterized by low-slung baggy pants, bare midriff tops, and visible bras, her look is now much more complex. Today, she liberally mixes fashions from different social classes and decades, and is heavily influenced by Japanese street style. She is feminine through and through, glamorous, and knows when to ditch an outfit.

Despite the new look, Stefani's transformation is not a change of image. It is more a development from kooky chick to feminine pop icon. The pouting singer has grown up, but managed to keep a consistent look with a high recognition value. Animal prints, hair dyed ultra-platinum blonde, heavy powder make-up for a porcelain complexion, distinctively curved eyebrows, and coral red lipstick are enduring factors in Stefani's look. That the natural brunette singer can pull off the rather tricky combination of peroxide bleach and leopard prints is a question of attitude. Stefani wears her outfits in an ironic yet intelligent way. And looks therefore not cheap, but stylish. An achievement which was last accomplished by Marilyn Monroe.

Actually her fashion labels L.A.M.B. and Harajuku Lovers are doing so well that cynical critics now call her albums soundtracks to the current collection. And Gwen Stefani thought she had no idea about fashion.

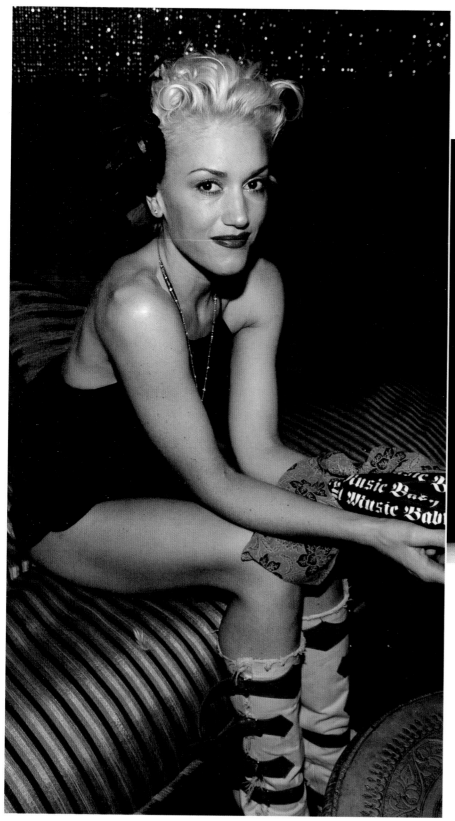

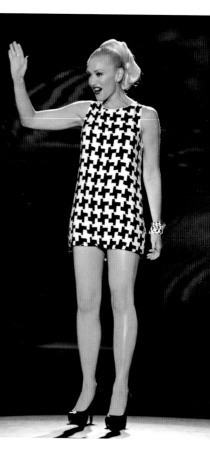

Gwen Stefani poses on the red carpet with her Harajuku Girls, Las Vegas, 2004

At a MTV party, Miami Beach; and at her L.A.M.B. label show, Mercedes-Benz Fashion Week, New York, 2007

>>
Stefani hosts a party to celebrate the release of her solo album *Love, Angel, Music, Baby,* Los Angeles; 2004, and performing in concert, Sacramento, 2004

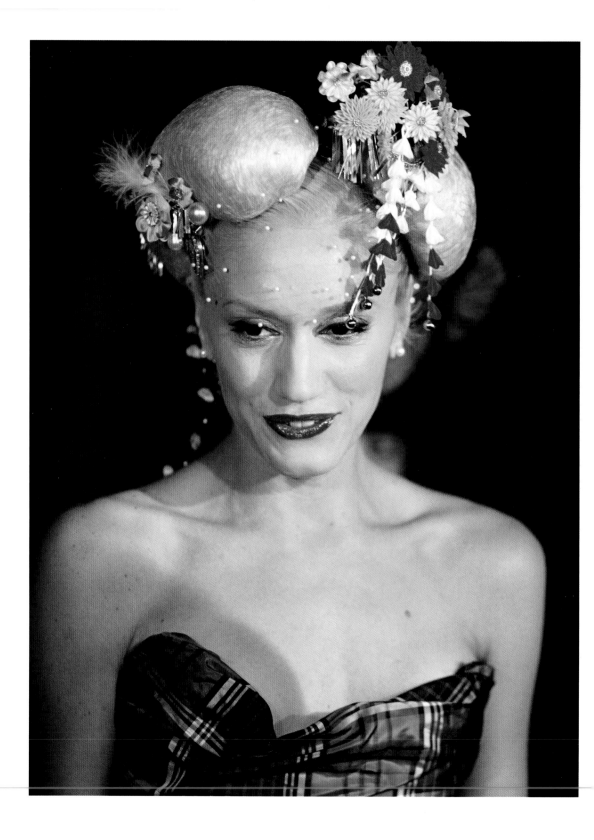

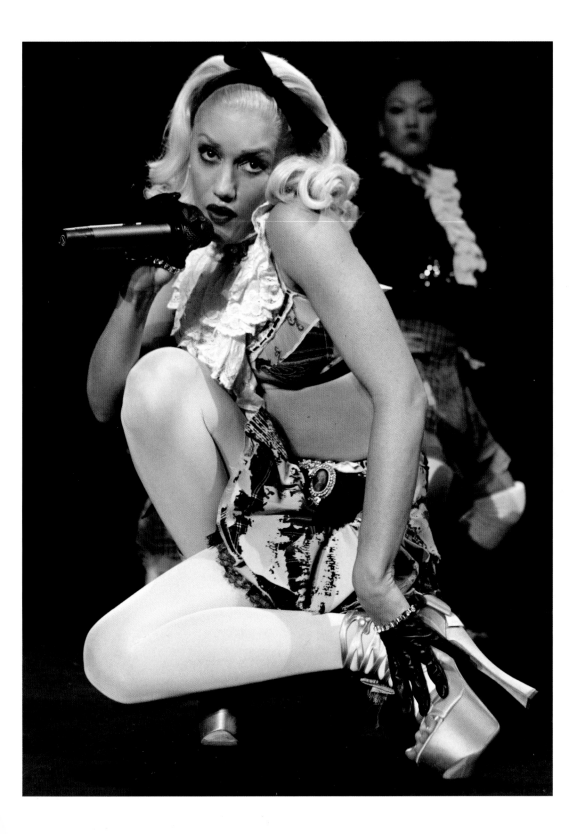

THE MOD

Coco Chanel
Sofia Coppola
Jil Sander
Katherine Hepburn
Carolyn Bessette Kennedy

ERNISTS

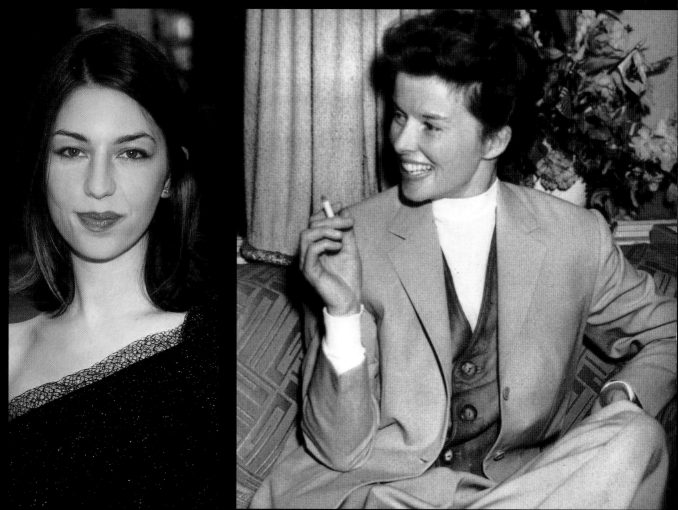

GABRIELLE "COCO" CHANEL

"Chanel's fashion is the quintessence of elegance." Vogue

Tweed suits, quilted bags with shoulder-length chains, camellias, and the legendary interlocking double-C—few designers have left as many monuments to their style as Coco Chanel—a fashion designer with anything but a promising background.

Born into poverty and raised in a monastery orphanage, she worked her way up in record time from ordinary textile shop assistant and occasional chanteuse to haute couture legend. At first glance, it was a very unusual achievement for a woman in the early twentieth century. On second thought, perhaps not. During her affairs with countless lovers (she never married), Chanel took note of what it took to be successful in business—vision, discipline, strategic thinking, and the ability to assert oneself. In addition, Mademoiselle Chanel had two weapons, the perils of which male business partners frequently underestimated— charm and sex appeal. She embodied the modern woman long before modern women populated the cities of the world in thousands. And her fashions were as avant-garde as she was.

"Fashion fades, only style remains the same."

What was so unusual about her jackets, skirts, and dresses made of jersey and tweed? The design! Chanel designed clothing that fit so perfectly women had time to worry about more important things than their appearance. She was ahead of her time: Chanel rescued women from flounces, tulle, and corsets, and made them fit for a life between the office, the golf course, and the yacht. She invented the little black dress, made costume jewelry

acceptable, and raised hems above the knee to a scandalous height. Society women got from her not only the famous tweed suit but the first comfortable pants as well. Chanel's outfits gave the women of the twenties true mobility for the very first time. Indeed, from the beginning mobility was the chief characteristic of the Chanel look. Her plain but luxurious designs followed the female body, while her collections kept pace with the spirit of a new generation. The charismatic designer herself described this act of liberation simply as "serving the wearer." She thus challenged her clients to be independent and self-sufficient. In order to feel comfortable in a suit by Coco Chanel, you had to be as strong and proud as its inventor. As it soon turned out, that applied to a great deal of women. Her tweed suits are still bestsellers.

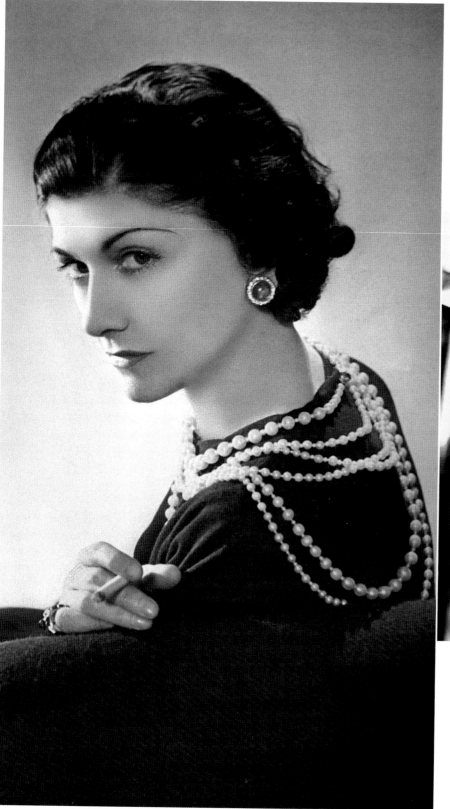

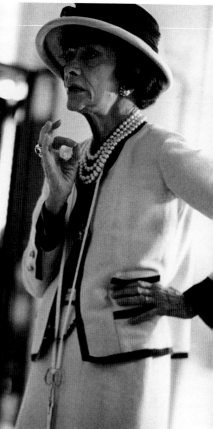

Coco Chanel,
1936 (left), and
1961 (right), Paris

>>
Coco Chanel,
1964 (left), and
1936 (right)

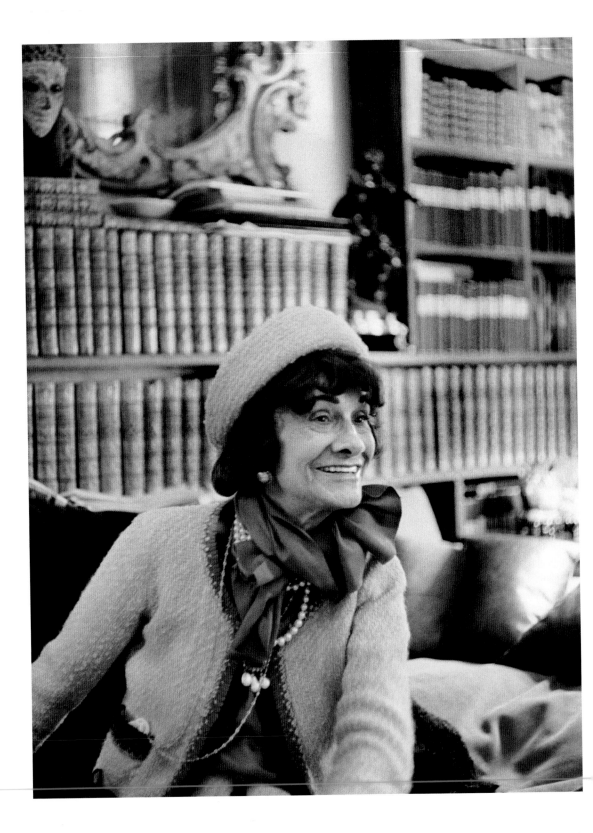

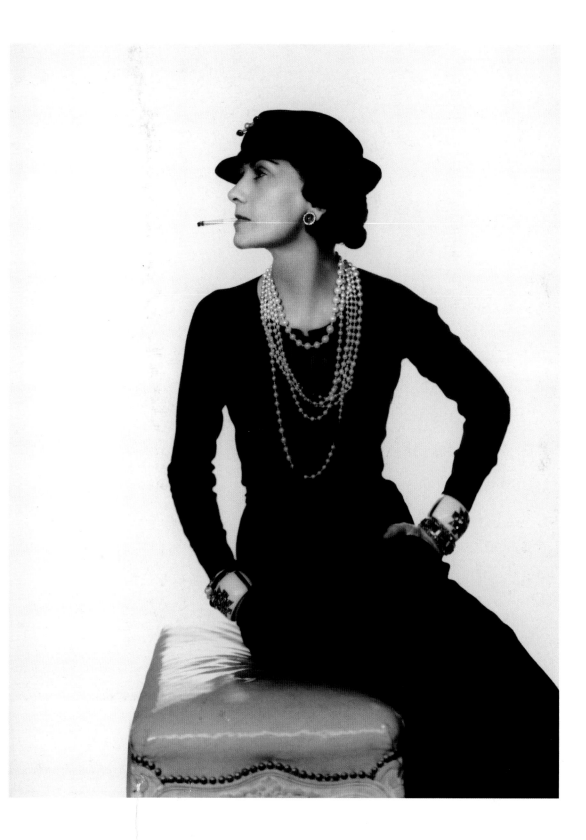

SOFIA COPPOLA

"I don't take fashion seriously, but I enjoy it."

Sofia Coppola breaks all the rules of the red carpet. She prefers flats to stilettos, and wears virtually no jewelry. She mainly opts for simple clothes in muted colors that conceal far more than they reveal. Her hair falls in casual waves, while her face bears only a trace of nude makeup. Nonetheless, the director is one of the best-dressed women in Hollywood. Coppola succeeds in making discreet understatement look glamorous. Her outfits have an aura of effortless chic; her look comes across as modest, up-to-date, and unobtrusively feminine. Although she is blessed with an enormous sense of style, one might even think that she was not particularly interested in fashion at all.

Yet it is not by chance that the Italian-American is an icon of style. As an eleven-year-old in high school, she was already wearing Chanel. Three years later, she was Karl Lagerfeld's assistant in Paris. At eighteen, she was a cover girl for *Vogue*. Later, she founded the fashion label Milk Fed, which is produced and distributed in Japan. Most recently, Coppola decided to become a film director, telling stories unique in their consistent production values and strong sense of visual detail. No, the style is anything but accidental.

Coppola is not only equally familiar with the demands of Hollywood and the fashion business, she is so from birth. And perhaps her handling of them is a bit more relaxed than others because of it.

She enjoys fashion, but won't be tyrannized by it. Her unconventionally attractive, self-confident elegance is inspiring—even for fashion designers. Coppola's favorite designer Marc Jacobs declared her his muse without hesitation. And indeed went a step further: "If I were a girl, Sofia's the one I'd like to be." Sometimes it's worth bending a few rules.

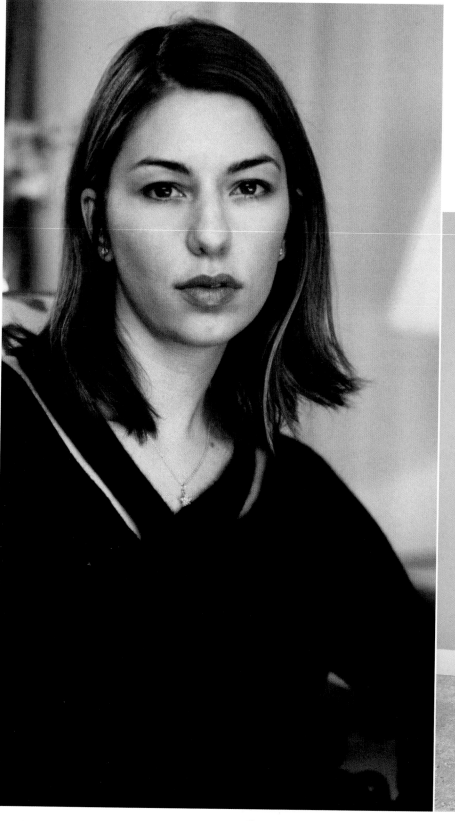

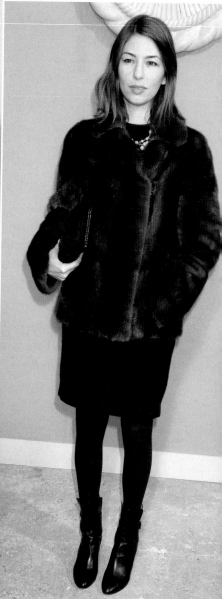

Sofia Coppola attends a gala dinner,
New York, 2004

In 2003; and attending the Chanel Fashion
show, Paris Fashion Week, 2008

JIL SANDER

"I find 'timeless' classic terribly boring. A classic is an excuse, because one is too lazy to confront the spirit of the time."

Some people are true to themselves from birth. Jill Sander is one of these rare beings. Endowed early on with an extraordinary sense of style, in the early fifties little Heidemarie Jiline Sander (her birth name) refused to wear the petticoats then fashionable—she preferred pants.

Twenty years later, after a brief spell as a fashion editor, Sander opened a boutique on Hamburg's upscale Milchstrasse—and moved even further from the delicate girlie look. The designs were oriented around a style all her own: clear, minimalist, self-confident. The cut was plain rather than simple, leaning towards avant-garde. Since the beginning, the light-blonde fashion designer steered clear of cliché—and was thus far ahead of her time. In 1975, Sander's show in Paris with unembellished lines and narrow silhouettes was an utter failure. Even so, the Hamburg designer saw no reason to tailor her style to the then popular vulgar-chic of Paris couture. She stuck to her guns and waited—and in the end was proven right.

Less than five years later, German women were increasingly making their way up the management ladder and needed a new look. Sander's perfectly made pantsuits in neutral colors mixed with fitted white tops and narrow trench coats became the uniform of a new generation of women—influential, self-assured, quality-conscious. Suddenly, the idea that plain could also be luxurious made sense, and in the early nineties extended worldwide—the international press dubbed Jil Sander the "Queen of Less."

In 2004, media-shy Sander finally retired from the fashion world—leaving behind a rich legacy. No one characterized the German style internationally as did she, who—already at age seven—knew who was wearing the pants.

Jil Sander in her
office, 1983

KATHERINE HEPBURN

"We're all in a serious spot when the original bag lady wins a prize for the way she dresses."

She loathed dresses, found make-up unnecessary, and cared nothing for public relations. Even so, Katharine Hepburn was not only one of the greatest film stars Hollywood ever produced, but also one of the greatest fashion icons of her day. And for one simple reason—nobody wore clothes with such imperturbable self-assurance as she did, despite wanting to have nothing to do with fashion.

As the middle-class daughter of a well-to-do, freethinking doctor and an ardent advocate of women's rights, Hepburn learned already as a child not to worry too much about the opinion of others. She was a tomboy and wore trousers from a very young age, something unheard of at the time. Years later the red-haired East Coast girl with the prickly charm never considered changing her clothes to conform to an ideal of beauty just because she wanted to be a Hollywood actress. For her first theatre audition she wore jeans and an overlarge man's sweater—and got the job. The film studio heads she later worked for were less impressed by her look: khaki-colored men's trousers, loose-cut shirts, baggy sweaters (which she generally tacked up with safety pins), and flat sandals, slip-ons, or tennis shoes. In contrast to Marlene Dietrich, whose erotic androgyny exploited the sex appeal of both genders, Hepburn's outfits were just plain male casuals, and the absolute antithesis of the full, opulent femininity then in fashion. MGM film studio went so far as to hide her clothes to get her to dress up off screen as well. But instead of giving in and complying with convention, Hepburn simply walked around the back lot in underwear until her beloved trousers were returned.

In the end, success proved her right. Not only did she win four Oscars (more than anyone before or since), but her pioneering style was the foundation for the classic sporty American look, easing the way for self-confident women who wanted a style of their own—even if it went against the grain.

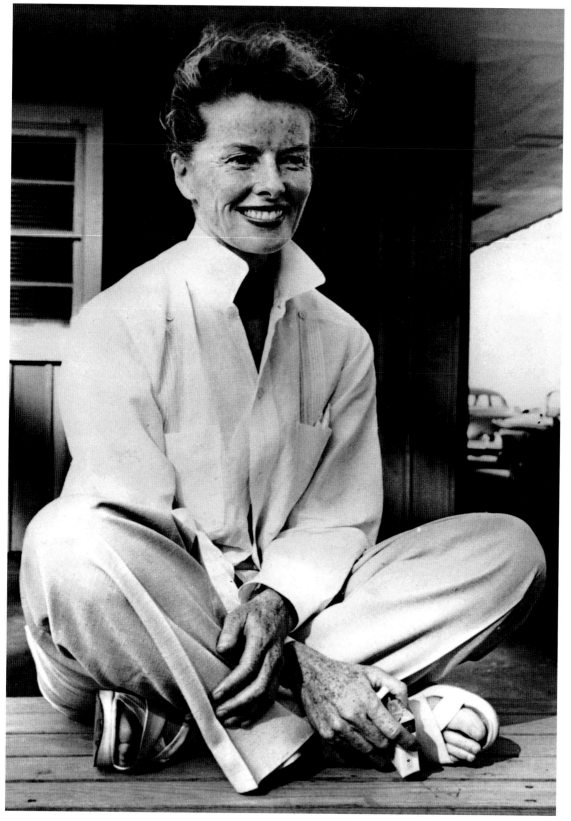

Katherine
Hepburn sitting
cross-legged on
her veranda,
1950

>>
Hepburn
wearing a cap,
and in portrait,
both 1950s

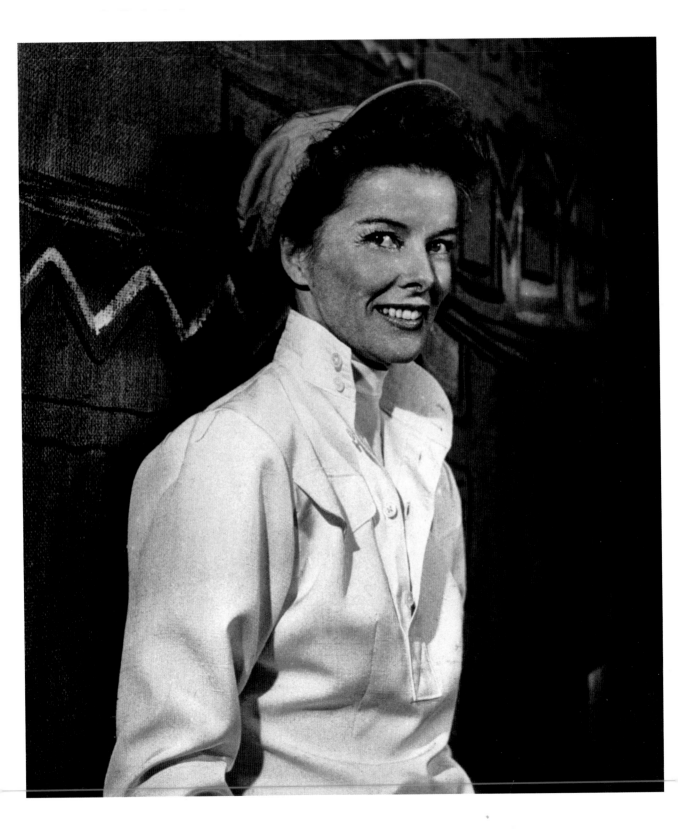

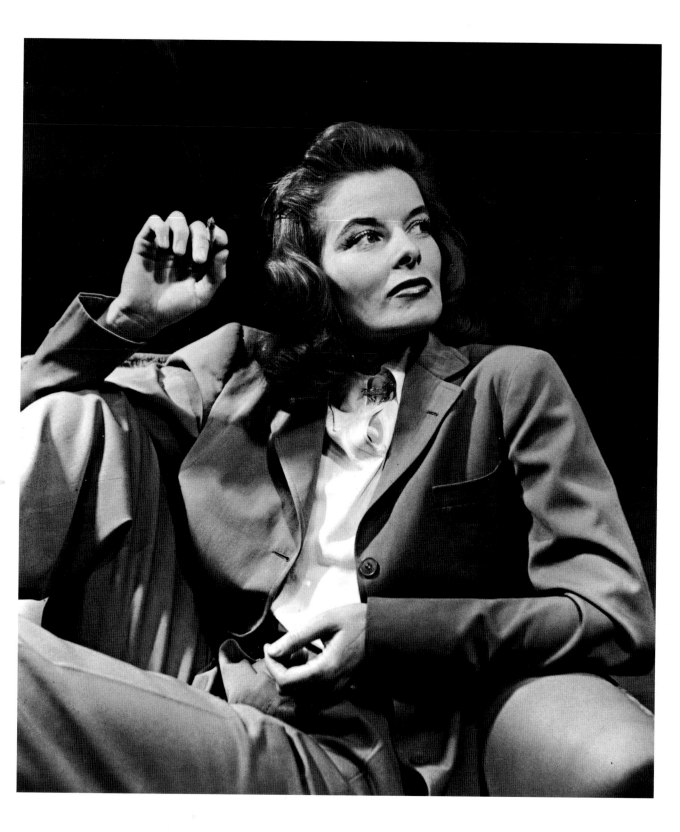

CAROLYN BESSETTE KENNEDY

"Her smart, minimalist sexiness made her instantly a gold standard of modern beauty."
Vanity Fair

When Carolyn Bessette Kennedy spoke of color, she probably meant black, grey, white, or at best beige. Certainly, her well-arranged wardrobe did not indicate the presence of any other tones. Without question: once she married John F. Kennedy, Jr. in 1996, she not only had the status of an American princess, but was above all the uncrowned queen of "clean chic," one of the most influential trends of the late nineties.

Even in her choice of bridal dress, the one-time PR adviser to Calvin Klein had the courage to say no thanks—and brought almost to the point of despair Cerruti couturier Narciso Rodriguez, the creator of her $30,000 wedding gown. The future Mrs. Kennedy was having none of the pearls he planned on embroidering into his design, nor anything else. The perfect tailoring of the dress was enough of a fashion statement. The only accessories were plain white gloves and a light, half-length veil draped almost incidentally over her right shoulder. Her hairstyle was a simple, casual knot above the neck.

Jackie Onassis's daughter-in-law manifested a similarly un-compromising attitude with her daytime wardrobe. The styling was plain, the materials of the highest quality, patterns taboo. The cool blond, who generally wore no jewelry, favored Prada, Yohji Yamamoto, and Calvin Klein. And yet society reporters rarely were able to identify the specific designers of her outfits for public appearances. Which was no accident. Kennedy insisted on visible labels or other indications of origin being removed, without exception.

Although the look came across as unforced, it certainly wasn't inexpensive. But it was worthwhile being uncompromising: where minimalist elegance is involved, the fashion influence of Caroline Bessette Kennedy has survived beyond her premature death.

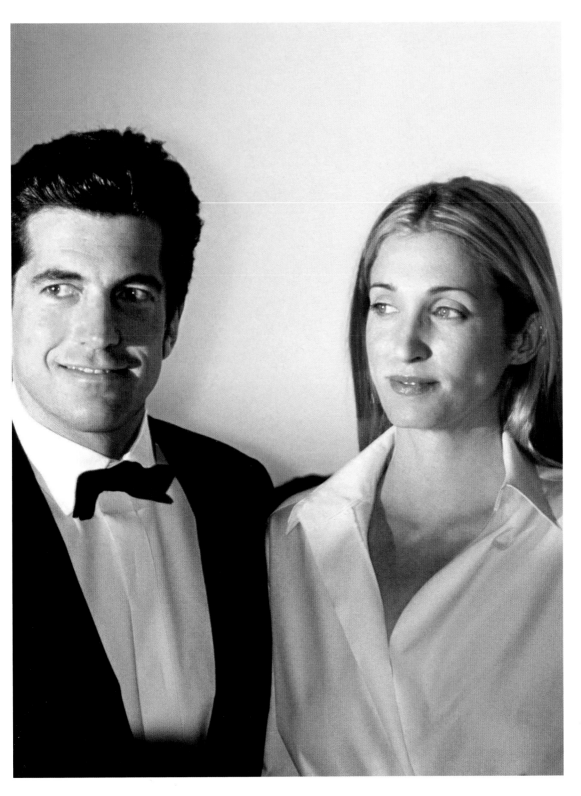

John Kennedy Jr.
and Carolyn
Bessette at a
fundraising gala,
New York, 1999

THE

Josephine Baker
Elsa Schiaparelli
Frida Kahlo

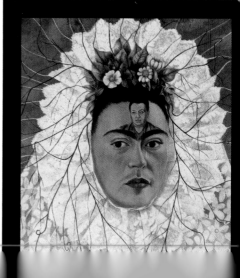

ARTISTS

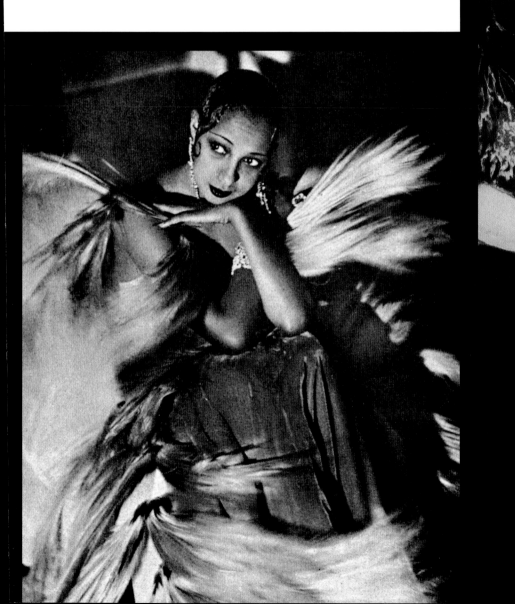

JOSEPHINE BAKER

"I wasn't really naked. I simply didn't have any clothes on."

Josephine Baker was the embodiment of good cheer. Nobody put sheer exuberance across better than she, or better represented the extravagance and decadence of the Roaring Twenties—in spite of a start in life that was anything but easy. Born in impoverished circumstances as the daughter of a washerwoman married to a chronically unemployed drunk, at sixteen she joined an itinerant vaudeville group. She even made the chorus on Broadway, though never the front row. Nor did she need to, because not much later she conquered the whole world from Paris. In 1925, a patroness took the young dancer to the French capital where Baker needed nothing more than a tiny banana skirt to win over the public.

In her first appearance (in the tiny skirt), she stalked the stage on all fours, her arms and legs rigid like a giraffe. Finally she broke into a wild Charleston, jiggled her backside frenziedly, pulled faces (along with her look, this became her trademark), and finally leapt into a tree erected on stage. The public was simultaneously horrified and delighted by the act, a perfect send-up of racist clichés, and Josephine Baker became an over-night star. With her playful eroticism, artistic acrobatics, and above all her sensational costumes, the dancer was the zeitgeist in visible form. Her stage outfits (standard components: rhinestones and feathers) were minimal, and so geometrical and high-contrast that Josephine Baker became a living art-deco statue in them, with her slender, almost machine-like stature. It was of course not a look that went down well everywhere. In Vienna and Munich her appearances had to be cut short, while Italy prohibited her entry. Exactly fifty years after her breakthrough, Josephine Baker had a grandiose comeback in 1975. Though she died soon after the premiere, the visual fireworks of her act will forever be remembered.

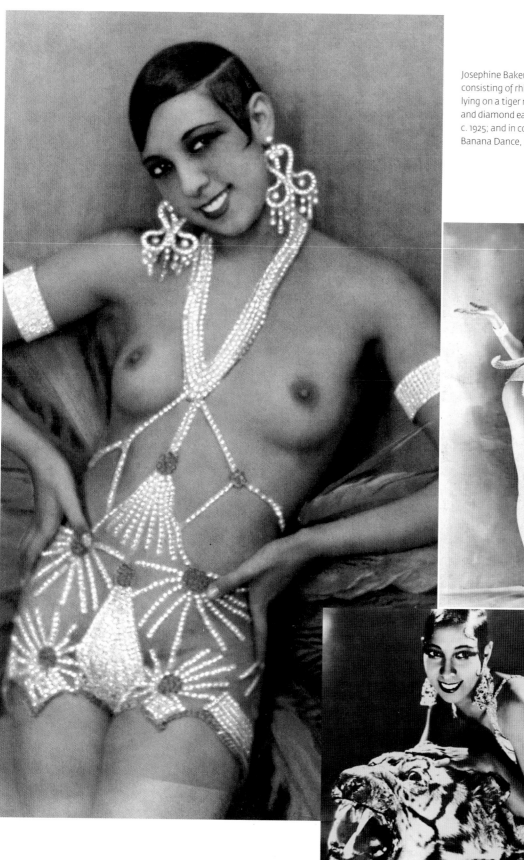

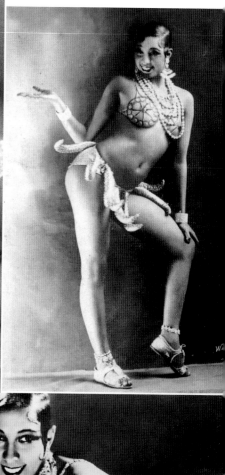

Josephine Baker in a cabaret costume consisting of rhinestones and feathers (left), lying on a tiger rug in a silk evening gown and diamond earrings (bottom), both c. 1925; and in costume for her famous Banana Dance, undated

ELSA SCHIAPARELLI

*"All women dress alike all over the world:
they dress to be annoying to other women."*

Her fantastic cloth works of art were more than mere garments. Although Elsa Schiaparelli promoted her designs as "good working clothes," they were anything but. The Roman-born designer introduced not only Surrealism into fashion, but one thing above all—bold, admirable creativity.

Shortly after her divorce in 1922, Schiaparelli—who was for the first time allowed to decide at age eighteen what she wanted to wear—settled with her daughter in Paris. Having no money and inspired by the artistic avant-garde (which she soon belonged to), she designed a first little collection of her own. And she immediately did credit to her later nickname "Shocking Elsa": her unusual sweaters decorated with artfully fluttering butterflies, sailors' tattoos, or lines outlining the thorax, were scandalous in the right way, and thus a total success with the Parisian upper classes of the prewar period. In her later haute couture designs, Schiaparelli demonstrated a Surrealist imagination, giving every collection a motif of its own. In doing so, she experimented not only with patterns and shapes but also with materials rarely used at the time such as glass fiber, cellophane, and sackcloth. But the most important characteristic was her connections with the art world: Cocteau drew embroidery patterns for fabrics, while the outsize crayfish on one of her evening dresses was by Dalí. She and Dalí also came up with the famous black velvet telephone bag with a gold dial. Elsa Triolet and Louis Aragon designed a necklace of aspirin tablets for the extravagant creations of the Schiap, as she was known.

With World War II, the expectations of fashion changed. Christian Dior's sober New Look and Coco Chanel's classy elegance set the tone for the new era, and there was no demand for Schiaparelli's fantastically extravagant creations. In 1952, forced to close her salon on Place Vendôme, the artist of haute couture retired to write her memoirs: *Shocking Life*.

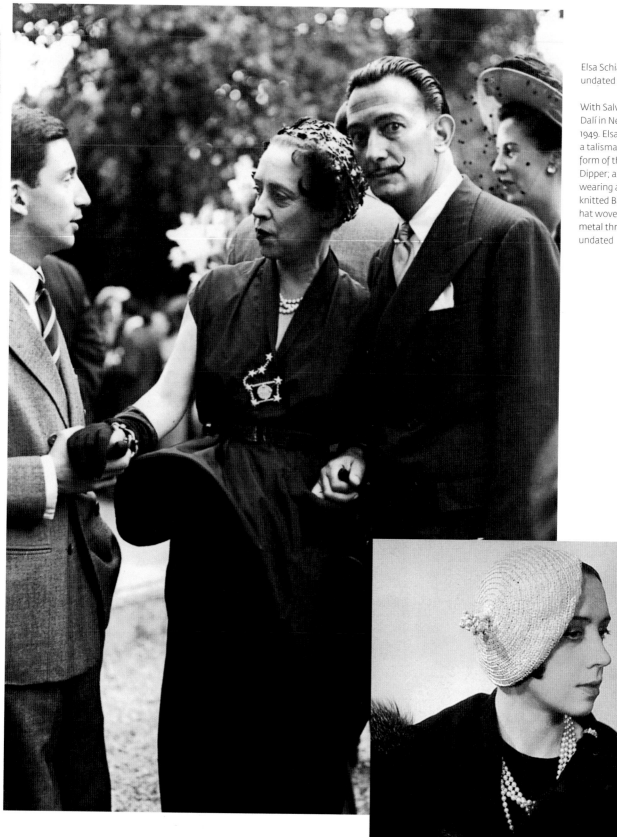

Elsa Schiaparelli, undated

With Salvador Dalí in Neuilly, 1949. Elsa wears a talisman in the form of the Big Dipper; and wearing a knitted Basque hat woven with metal thread, undated

FRIDA KAHLO

"I'm always rushing around like crazy and have got used to these very old clothes. Meantime, even a few gringo women imitate me, trying to dress Mexican, but it makes the poor things look like turnips."

In her self-portraits, Frida Kahlo looks gravely at the viewer. Not directly, but holding her head to one side. Her heavy, arched eyebrows are dark and meet at the bridge of the nose. Above a full, sensual mouth, which never shows even a hint of a smile, is the tender down of a faint moustache. The self-portraits of the Mexican artist reveal not only a richly faceted woman with a profound spirit but also document her personal style in all its complexity.

Regardless of whether she was wearing an oversized men's suit or brightly colored folkloric dress, Frida Kahlo had little room for convention, either in her tragedy-scarred life or in her wardrobe. She made a point of using clothing to accentuate her Mexican origins. That's why her favorite pieces included brightly colored *huipiles*, the caftan-like garment of Indian women, and original Mexican skirts, blouses, and accessories. But Kahlo's approach to these was not always strictly traditional—she enjoyed contrasting combinations of colors and styles. She added to her attractively presented identity in the choice of jewelry and hairstyle: braiding her hair in a typical Indian fashion and decorating it with fresh flowers and colored ribbons, artfully woven about her head into a wreath.

Frida Kahlo used her wardrobe to make a deliberate point. She self-confidently wore her favorite styles not only in her homeland, but also in New York, Paris, and San Francisco. The fact that socialites there were much taken with her striking looks and soon appropriated elements of her style rather amused her. For Kahlo, however, dress was more than fashion and masquerade.

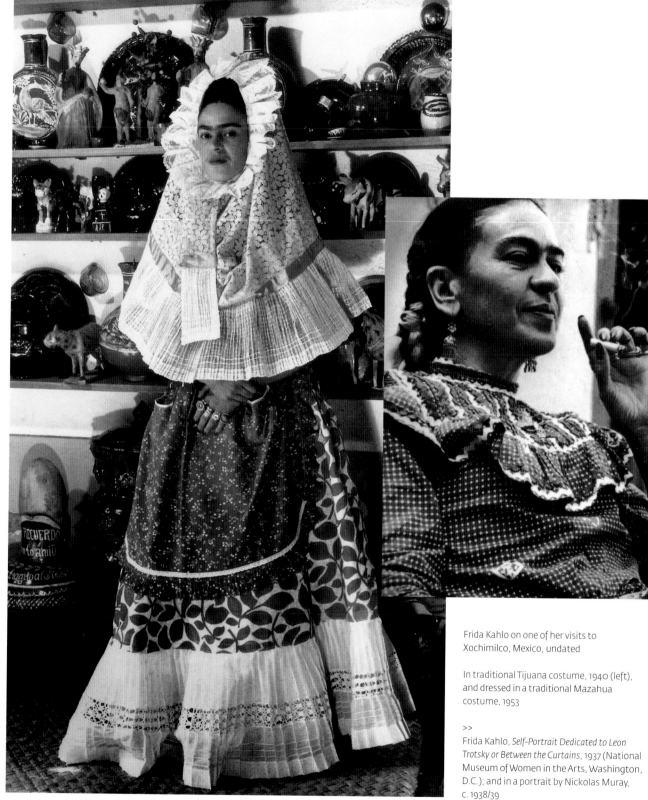

Frida Kahlo on one of her visits to
Xochimilco, Mexico, undated

In traditional Tijuana costume, 1940 (left),
and dressed in a traditional Mazahua
costume, 1953

>>
Frida Kahlo, *Self-Portrait Dedicated to Leon
Trotsky or Between the Curtains*, 1937 (National
Museum of Women in the Arts, Washington,
D.C.); and in a portrait by Nickolas Muray,
c. 1938/39

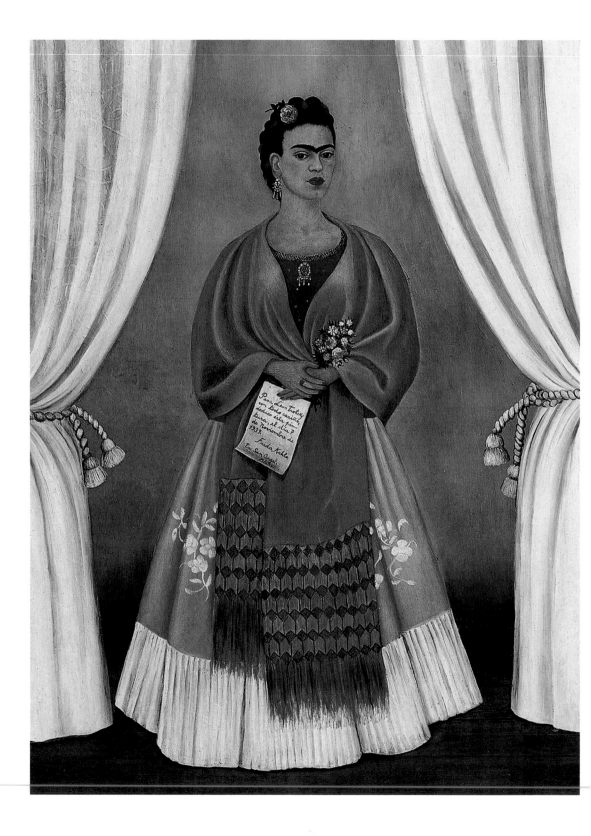

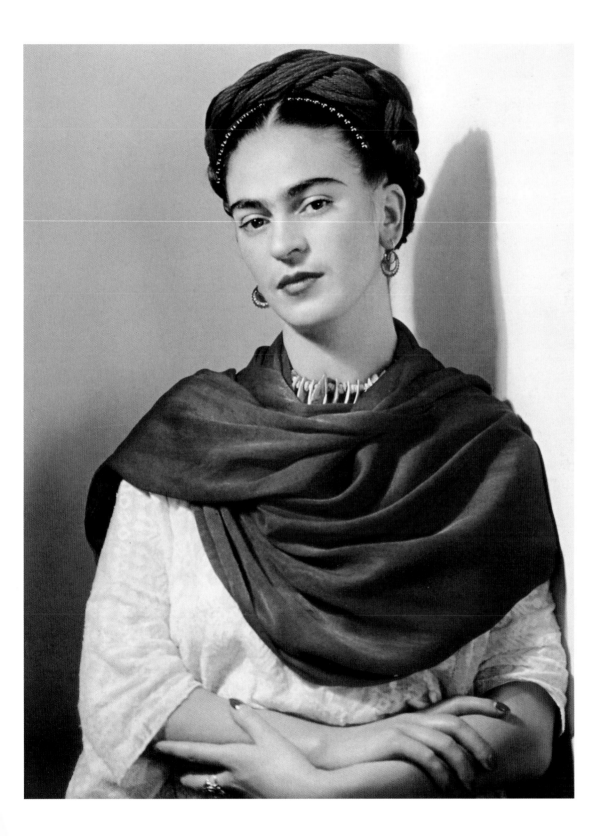

THE

Joan Crawford
Dita von Teese
Marlene Dietrich
Diana, Princess of Wales
Scarlett Johansson
Suzanne Lenglen

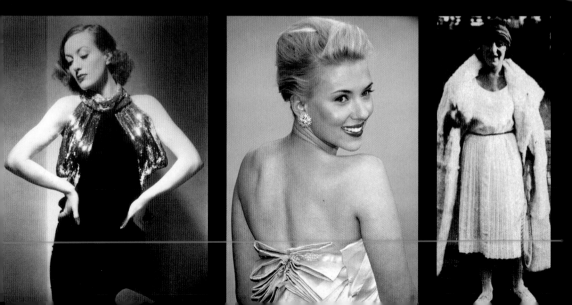

DIVAS

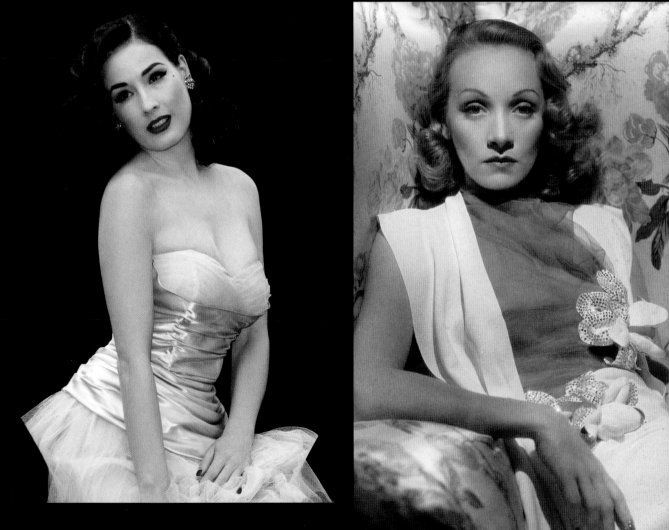

"1. Find your own style and have the courage to stick to it.
2. Choose your clothes for your way of life.

JOAN
CRAWFORD

3. Make your wardrobe as versatile as an actress. It should be able to play many roles.
4. Find your happiest colours—the ones that make you feel good.
5. Care for your clothes, like the good friends they are!"

The screen stars of Hollywood's golden age were more than just actresses. A woman of the thirties and forties who wanted to know about the latest fad didn't necessarily look to fashion magazines. To keep up-to-date, most style-conscious women went to the cinema instead of paging through *Vogue*. And just like that, the greatest model in fashion matters turned out to be Joan Crawford, who took her job as a style icon very seriously.

From a humble background, Crawford was completely obsessed with clothes. In her films, dressing her often cost more than the screenplay itself. In her private life, she changed outfits up to ten times a day, sometimes every hour, in order to match the occasion. She even had a separate outfit for reading and answering her fan mail (she was one of the few stars who, all her life, personally answered every letter). On most of her trips she went with no fewer than thirty-five pieces of luggage that contained a wide variety of looks, along with matching accessories, shoes, hats and gloves, and a plethora of diamond jewelry. Guests who visited Crawford at home were conducted through several of the hostess's walk-in wardrobes as the high point of the occasion. If she had a particular liking for an accessory or garment, she immediately had it made in a dozen different colors. Even the vodka-filled hip flask, an indispensable companion, was coordinated to the color and pattern of her outfit. It was not just Joan Crawford's enormous expenditures on her appearance that were remarkable; just as impressive was her criteria in selecting clothing. Crawford was not Hollywood pretty in the traditional sense. She had more of a fear-inspiring beauty, with extraordinarily broad hips and shoulders. But instead of trying to cover up these "blemishes," she and Gilbert Adrian, MGM's chief designer at the time, decided to emphasize them. Adrian designed cloth masterpieces for the actress that made her shoulders a grandiose part of the scenery. Joan Crawford was no ordinary fashion icon, she was the "queen of the shoulder pads," and marked a trend that after lasting a mere ten years celebrated a fulminating comeback in the eighties.

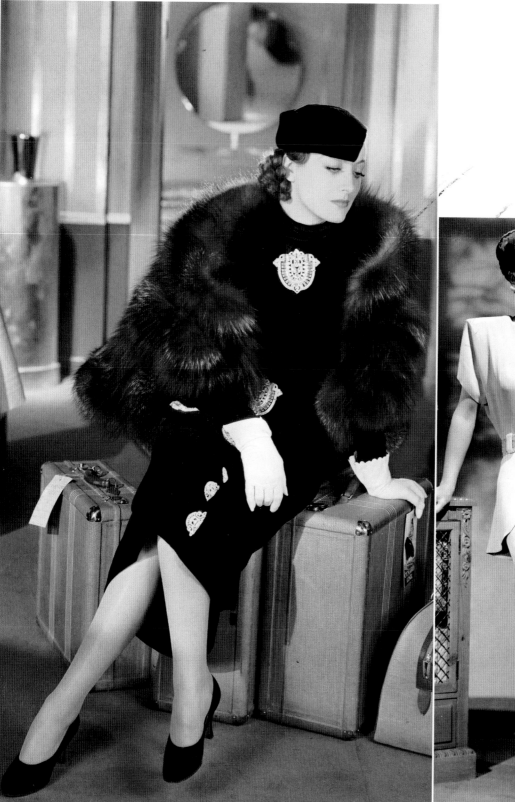

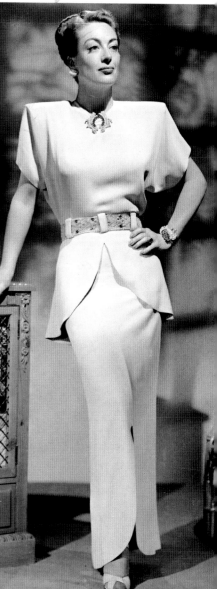

Joan Crawford,
in a travel outfit
(left), 1934; and
with shoulder
pads, 1944

DITA VON TEESE

"Extravagance means to me having an unmistakable style."

She rides crystal-studded fairground horses, emerges from giant gilt powder compacts, and bathes in oversized martini glasses as a seductive mermaid. The Dita von Teese show is more than mere striptease. The burlesque artiste not only has tremendous sex appeal, but above all glamour—on stage and off.

There is probably no point in looking for jeans and tracksuits in her pink dressing room. What you will find is over three hundred tailored corsets (she can lace her waist to sixteen inches), luxuriously tailored evening dresses in dramatic colors, ultra-feminine suits, and an ample store of fancy vintage pieces. Dangerously high stilettos, seamed stockings, elbow-length gloves, and glamorous fur stoles round off the retro outfits of the burlesque superheroine. But great theatre not only calls for breathtaking clothing, it also calls for dramatic make-up: with an alabaster white complexion, perfectly styled glossy black hair, tattooed beauty spot, and meticulously applied carmine lipstick, von Teese transforms her natural freckled blonde appearance into a mix of femme fatale and modern Snow White. Probably most noticeable is the fact that the burlesque artiste's figure-hugging look inspired in the 1940s (trademark: extremely slender waist and prominent shoulders) never reveals too much.

Of all celebrities, it is Dita von Teese who offers the antithesis of sexual excess among all the Hollywood exhibitionists.

The American diva's look leaves room for fantasy—and lends the wearer an air of superiority.

Dita von Teese's secret is that she does not distinguish between the stage, the red carpet, and everyday life. She sticks to her style whatever the occasion, regardless of the expense and discipline required to keep up her appearance. And this is the very reason why von Teese, whose job actually is to take her clothes off, manages to wear them with more glamorous matter-of-factness than anyone else.

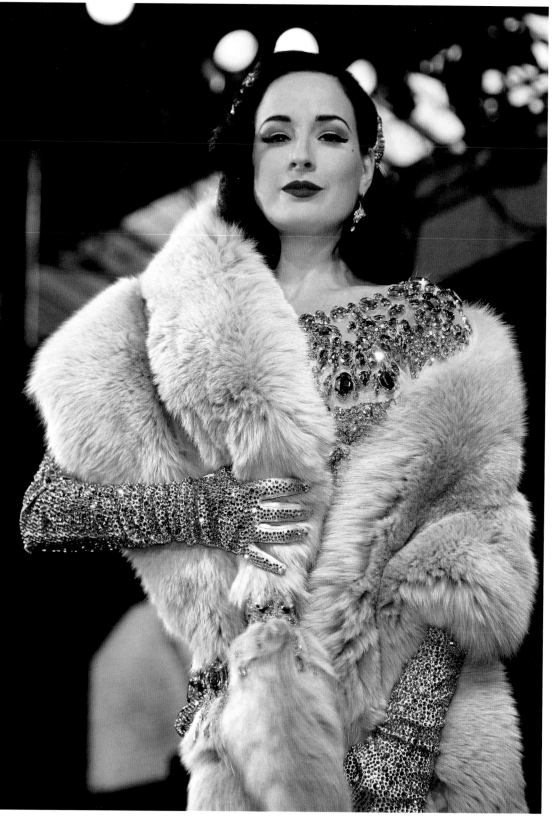

Dita Von Teese
attends the Paris
Fashion Week,
2008

Dita Von Teese in
London, 2007

>>
Von Teese in
2007; and in a
burlesque outfit,
undated

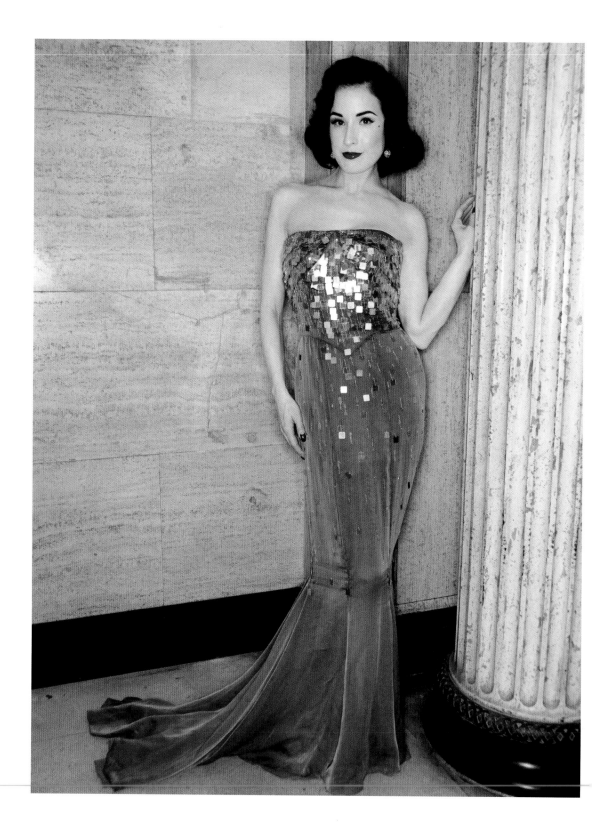

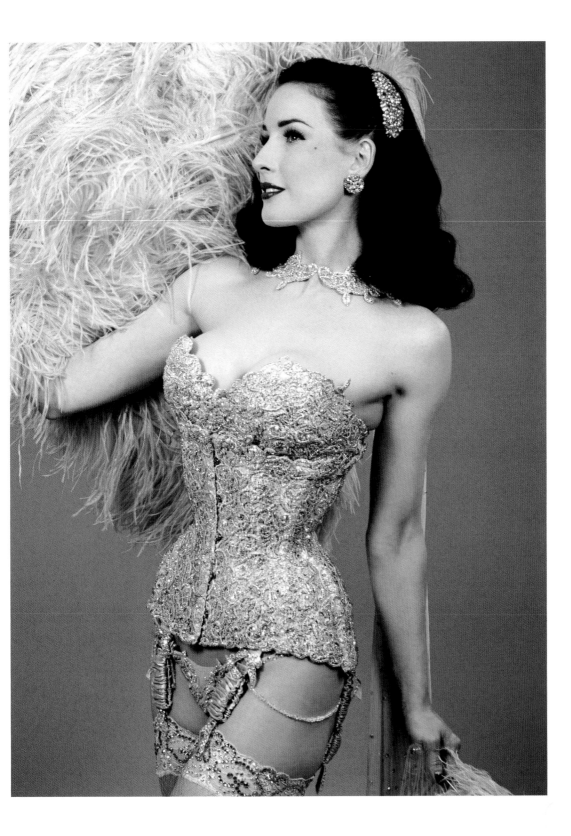

MARLENE DIETRICH

"People laugh at yesterday's fashions, but we rave about fashions of the day before yesterday if they look like becoming tomorrow's fashions."

When in 1929 director Joseph von Sternberg was casting the part of nightclub singer Lola Lola for his film *Blue Angel*, he came across the thirty-year-old unknown Berlin actress Marlene Dietrich. He was immediately fascinated by her provokingly masculine but nonetheless infinitely erotic aura. Sternberg instantly set about molding the rough diamond he'd found into the femme fatale he needed. At his request, Dietrich shed over twenty pounds, had her back teeth removed to emphasize her already well-shaped cheeks, and sang *Falling in Love Again* sitting on a wine barrel, wearing garters, high-heeled shoes, and a top hat on her blonde head. The film was a worldwide hit, and Marlene Dietrich became an international star—and moreover one who henceforth would make her own decisions about her image.

The newly minted Hollywood actress took a strictly strategic approach to her choice of clothes. She emphasized what was worth emphasizing (her legs were legendary, even in her lifetime) and covered up what seemed less attractive to her (she herself was never a fan of her quite fetching cleavage). And, unlike most of her fellow actresses, she didn't have herself fitted out by the film studios. Even for her screen outfits, she reserved the right to be consulted—down to the accessories and the lighting used. Of course, her greatest coup was to recognize that she was woman enough to wear men's clothes. The tuxedos, suits, jackets, and trousers she wore were thoroughly masculine, yet on Marlene Dietrich they were unsurpassed in sensuality and glamour by any dress (which, as it happens, also looked terrific on her).

At a time when an androgynous mixture of styles was not only completely unknown but also carried an air of inde-cency, Marlene Dietrich's look smoothed the way for modern female fashions. And her attitude about herself was just as strict and high-risk as her attitude about her outfits. At the end of the seventies she retired completely from public view and spent the rest of her life almost exclusively in her Paris apartment. The world was to remember her as she preferred to see herself—strong, beautiful, and mysterious.

"What's glamour? No one has explained the word. It means personality, often beauty, but authority in any event."

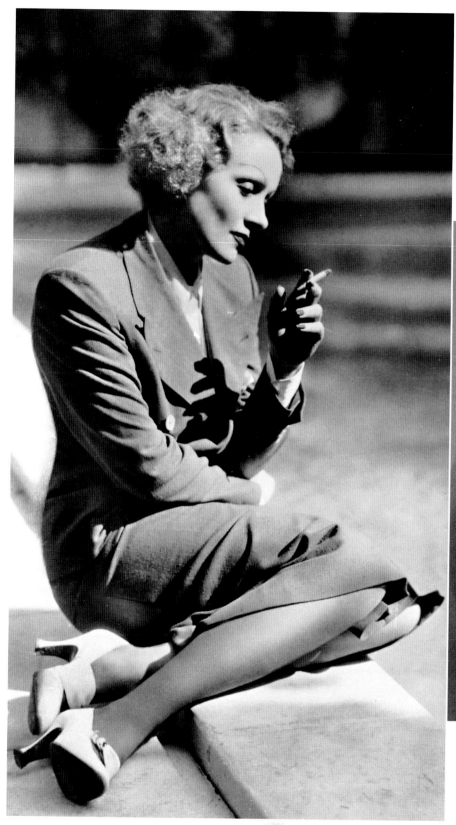

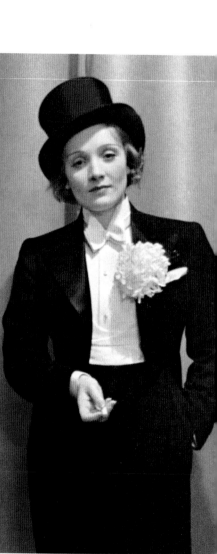

Marlene Dietrich smoking a cigarette by her swimming pool in Beverly Hills, 1930s; and wearing a tuxedo, 1929

>>
Dietrich casually dressed in a shirt and loosened tie, 1932; and in portrait, 1956

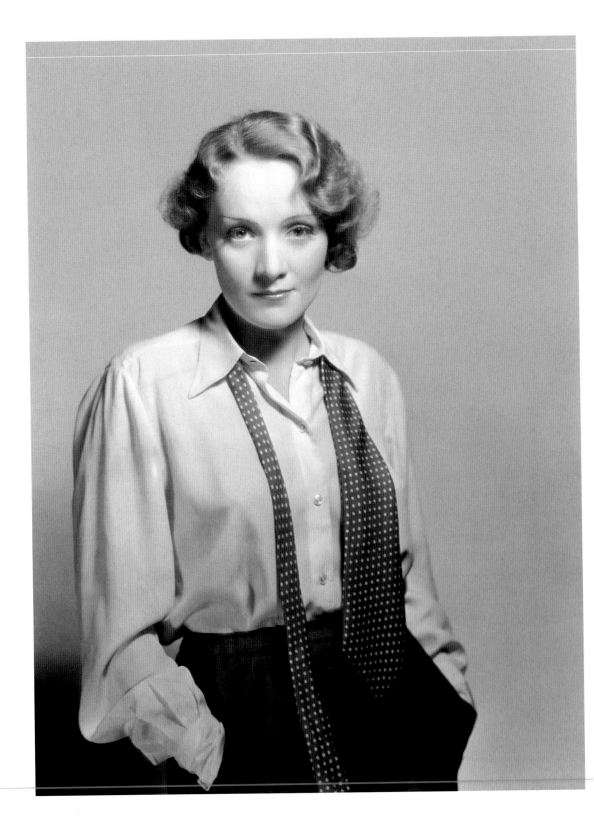

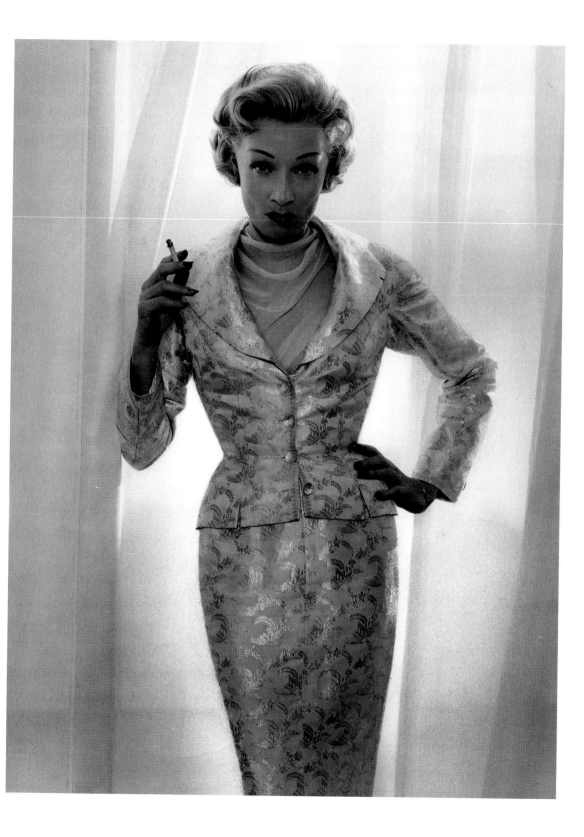

DIANA PRINCESS OF WALES

"Princess Diana truly was England's rose. She had a magical aura about her. I always felt she really understood how to use fashion as the silent language and let clothes do the talking for her when she couldn't, the way a movie star in the silent films did." John Galliano

There has rarely been a less spectacular first public appearance. Nothing suggested that the insecure girl in the uninspiring combination of a calf-length skirt and a white sweater vest would soon become the most photographed woman in the world. Only the lack of a slip provided a little excitement, which showed how inexperienced Lady Diana really was in handling the press in 1980. That soon changed. No one developed from mousy wallflower to glamorous style icon so sensationally, and no one used fashion so aggressively for her own PR as Diana.

In her first years as a princess, Diana was a frilly blouse personified. Her wedding gown by designers David and Elizabeth Emanuel was reminiscent of an overlarge cream meringue which didn't even fit properly. Although the Princess still lacked a sense of style, her English upper-class look was copied worldwide. The Diana effect had already begun.

After the birth of her two sons, the princess with the famous simper had had enough of knee-length socks and patent leather slip-ons. Diana bid farewell to the court tailor and discovered English designers along with the eighties look. For the first time, she wore off-the-shoulder dresses, which would become one of her trademarks. Her new style was more than a change of outfit, it was an act of liberation, a declaration of war on the royal family. And her greatest weapon was her style. With her separation from Prince Charles in 1992, Diana finally cut loose. She cut the slack from inflated, blow-dried hairdos and wore international couture. Her outfits became more and more elegant and figure hugging—and a notch up in their minimalist glamour. Her "clean chic" radiated self-assurance. She had never been so beautiful.

At the end of the nineties, Diana auctioned off many of her dresses. She didn't need fashion for self-confidence. Her personality now radiated a greater aura than any dress. It seems as if, shortly before her mysterious death in a Paris car accident involving the paparazzi, the shy girl of yore was finally where she wanted to be— at ease with herself.

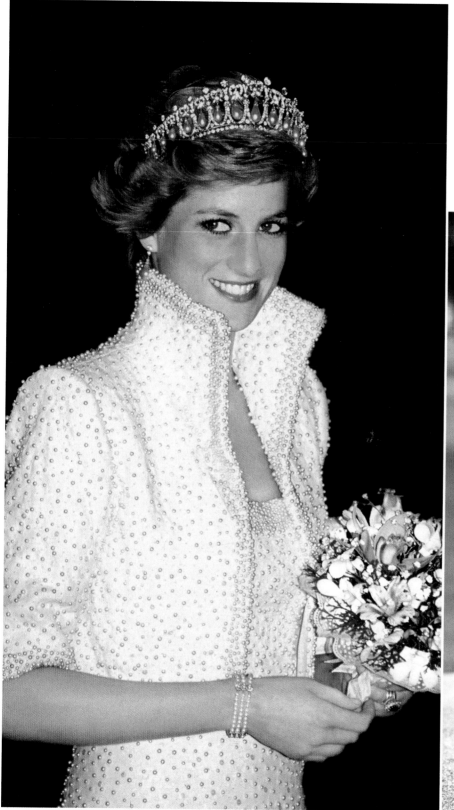

Diana, Princess of Wales, arrives at the Royal Albert Hall, London, 1997

Wearing an outfit designed by Catherine Walker (left), Hong Kong, 1989; and in a dress by Christina Stambolian at the Serpentine Gallery, London, 1994

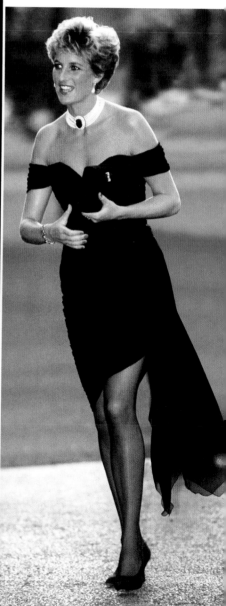

SCARLETT JOHANSSON

"I don't do fashion magazines. I watch Lana Turner."

Girls, or rather women, like Scarlett Johansson have become rare. Although the New Yorker is neither patently hip nor experimental, she does have the kind of glamour that doesn't really exist any more. Johansson has the expressiveness of a silent film star—and knows how to use it to her advantage.

Her appearances on the red carpet evoke a *dolce vita* once thought forgotten but difficult to escape.

"Just because I make films that have a low budget doesn't mean I should dress low-budget. If you go to a glamorous event, you should look glamorous."

Everything about Johansson seems unique. Her milky pale porcelain complexion is at best peachy elegant, while her rather overlarge, pouting mouth gives the actress a naturally glamorous but innocent look. Her figure is that of a satin doll of yesteryear, though almost too opulently feminine for the current fashion. But Johansson has no intention of changing any of that. She takes her sensual shape for granted, and in doing so makes young Hollywood seem like a children's birthday party turned androgynous.

The platinum-blonde actress knows what suits her, and hardly anyone fills clothes as advantageously as she. In corsage dresses like those by her favorite designer Roland Mouret, her décolleté has breathtaking impact, while the accentuated waists of her tailoring emphasize her feminine form. Although Johansson

herself is only in her mid-twenties, her wardrobe has long been adult. Her look is erotic but never vulgar; her diva-like elegance is clearly inspired by 1940s Hollywood. And yet she never looks dolled up. On the contrary: she merely follows her own path, choosing a look that is not forced but rather perfectly befitting her shape. The beautiful result is a mysterious aura that is always there but nonetheless intangible—of the very kind that is so rare today.

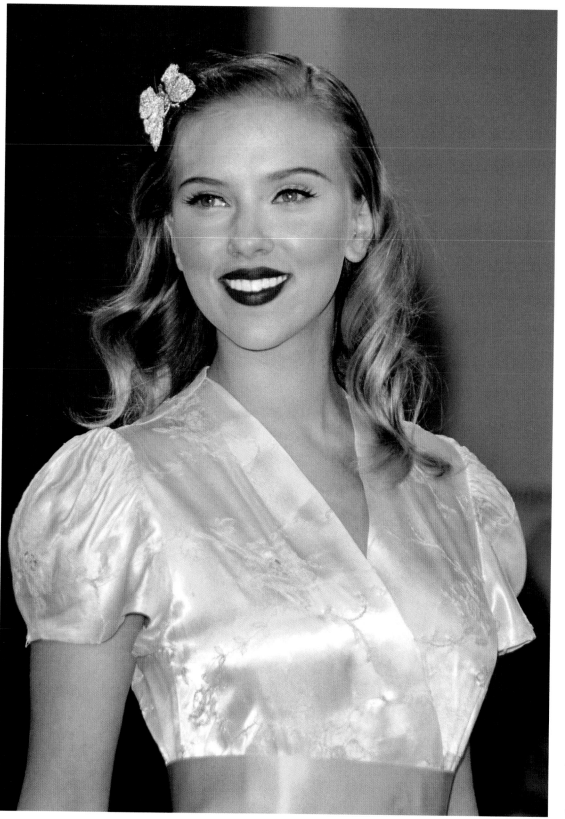

Scarlett
Johansson
at the 63rd
International
Film Festival,
Venice, 2006

SUZANNE LENGLEN

"Her tennis is like her personality—a thing of dash and snap and verve."
The New York Times

Anyone watching women's tennis in the early twenties knew what to expect—the competing players well wrapped and properly covered in corsets and ankle-length dresses. Under no circumstances would they have shown themselves as anything but modest and ladylike. And then Suzanne Lenglen came along. Everything about the French player seemed scandalous at the time, though it may seem par for the course in modern women's tennis: a control-freak father, public mood swings, and on-court tantrums. But then again, she did carry off thirty-one grand slam titles—fifteen from Wimbledon—and two Olympic gold medals. Almost even more impressive than her sporting successes however was the entirely new glamour and grandiose gesturing that Suzanne Lenglen brought to the tennis court.

She normally walked out onto the court in a swirling, open mink coat. What was underneath caused at least as much stir. Known to the press and her fans alike as "the Divine," she played her games in delicate silk creations by Jean Patou that inflamed the minds of spectators and organizers alike with sleeveless calf-length dresses and plunging necklines. Though Lenglen covered her ankles with white socks, she refused to wear a slip. Instead of a hat, she wound a pure silk colored scarf round her head, thus not only looking much better than her rivals but also actually seeing better. Her favorite ritual on changing ends was not only to touch up her makeup but also to take a generous swig of brandy from the hip flask she carried around—for refreshment, she claimed.

Astonishingly, despite all the scandals, Suzanne Lenglen was never sent off the court. Though she only lived to the age of thirty-nine, she remains one of the most successful female tennis players of all time, and one of the most chic. What a rare combination.

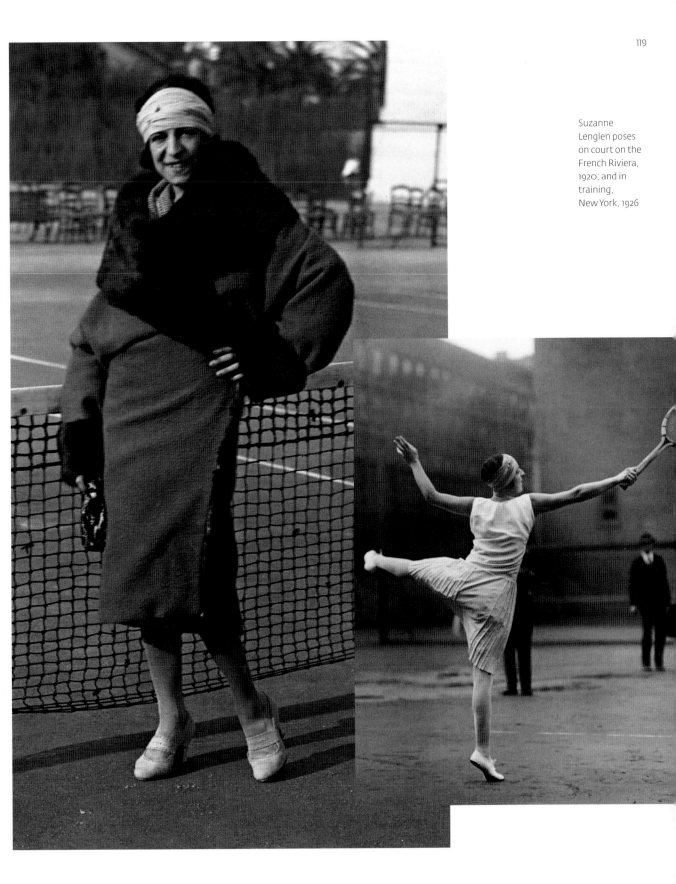

Suzanne Lenglen poses on court on the French Riviera, 1920; and in training, New York, 1926

THE ECC

Anna Piaggi
Björk
Isabella Blow
Diana Vreeland
Grace Jones

ENTRICS

ANNA PIAGGI

"I feel better if I have a good hat on."

She can't exactly be accused of having a feel for discriminating understatement. But then again, she does take boundless pleasure in colors, patterns, and dramatic appearances. Anna Piaggi is a highly successful fashion journalist, a bird of paradise among her colleagues.

A glance in her closet would prove that less is not always more: the 31 feather boas, 289 necklaces, 29 fans, 45 tubes of lipstick, 265 pairs of shoes, 932 hats, 2,865 dresses, 399 jackets, and 745 tops form the broad foundation of her inimitable style. What's more, the colorful Italian has a weakness for antiques. Among the numerous items in her possession are a black negligee from 1909 worn by Josephine Baker, an African warrior's outfit, an opulent evening gown from a performance of *La Traviata* at Milan's La Scala, and a richly embroidered, late-nineteenth-century cashmere shawl once belonging to the Duchess of Somerset. Yet despite all her love for originals from the past, Piaggi is not bent on recreating faithful pastiches of past fashions. She does not even appear to collect her clothing according to a clearly defined concept, so why should she stick to the rules of so-called good style? Instead, she uses her intuition when she opens her closet to come up with endlessly new, guaranteed theatrical, and un-doubtedly novel combinations. The only thing she takes into ac-count is the location where she is to appear with her outfit. She may even go so far as to pay a previous visit to the location of a major event, so as to (as she says) visually prepare for her outfit. The only constants in her look are blue-tinted locks and cherry-red lips. Otherwise, she never wears an outfit more than once.

The greatest fan of Anna Piaggi's style is incidentally Karl Lagerfeld, who has sketched hundreds of her legendary outfits. The result of his work is not only a tribute to the most colorful bird of paradise in the fashion world, but above all proof that more can indeed sometimes be more.

Anna Piaggi
during London
Fashion Week,
2004

"I like the creative angle [of fashion]. Where people express themselves. But I don't like it when it's too much people being told what to do, and too much like ... fascism, magazines telling women to starve themselves, and they obey! Or they're, like, 'out of fashion,' which is the worst crime you could ever commit! So they get executed for it, publicly! It makes women very unhappy."

BJÖRK

Sometimes a a single dress is enough for an image to stick in your mind forever. In Björk's case, it was a swan dress. Or more precisely, an ice-skater's tulle tutu from which a white-feathered imitation swan neck rose to embrace the singer. Her accessories were six eggs to be laid on the red carpet. That was 2001—and Björk is surprised at all the fuss still made about this one dress. Understandably, since the Icelandic singer has more to offer than just one outfit.

Björk's style is innovative in the true sense of the word. What she wears no one has ever worn—nor probably ever will. Just as she has no interest in following trends, Björk has no interest in starting them. Her outfits are not calculated, nor are they fashion in the traditional sense. They are more in the way of conceptual experiments that raise her every appearance to the level of art.

The musician with brownish black hair and almost Asiatic features gives primacy to her visions, quite willing to sew pearls to her skin if it serves a purpose. Björk chooses her clothing by instinct and with her soul, like a child that has no fear of the judgment of others. She fearlessly mixes styles—folklore, vintage, and avant-garde—into endless new looks, all of which are complicated but never artificial. The result generally comes across as remarkable, droll, strange, dangerous—and somehow always a little cute. Björk's look is a mixture of delicate Icelandic fairy and

belligerent comic-book character. It's not a style that can be imitated, any more than it can be universally understood—unfortunately. Because Björk is like a rare window on a world full of magic and adventure—and without a window like this, music and fashion would be a whole lot more boring.

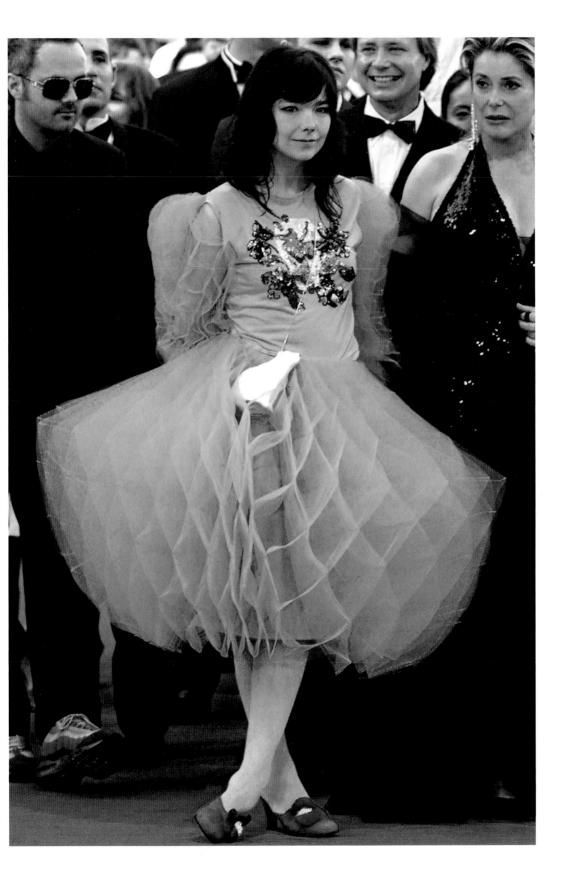

Björk wearing
her legendary
Marjan Pejoski
swan gown,
73rd Annual
Academy
Awards,
Hollywood,
2001

At the Cannes
Film Festival,
2000

>>
Performing
during the
opening
ceremony of the
2004 Olympic
Games, Athens;
and seen
backstage at a
fashion event,
London, 2003

ISABELLA BLOW

"At my age, it's much easier to seduce a man in a hat than without one. I need hats to be seductive, otherwise I'm lost."

Finding Isabella Blow was never a problem—she was the lady wearing a hat. At fashion shows, she regularly took the second row's view away—and then their breath. Blow's headpieces were not the kind you wore to the races.

The fashion editor was eccentric in the best British tradition. No one combined tradition and the avant-garde as excitingly as she did; no one lived fashion with so much pleasure; and no one wore outrageous headgear with so much grace. Without lipstick, a laced-up bodice, décolletage, and high heels, Blow would never have left the house.

London-born Blow was what the French would call *jolie laide*—attractive, but not pretty. She knew how to make the best of herself. She made a daring spectacle of her head, crowning her not exactly perfect face with jewel-studded lobsters, outrageous feathered creations, or a cleaved, orange plastic disc.

She would never have considered going in for cosmetic surgery. It was so much easier simply to put a hat on—of course, preferably one by Philip Treacy. Blow discovered him when he was still a student. In fact, her greatest skill lay not in wearing fanciful clothes. Her greatest talent was recognizing it in others. Countless fashion designers or models such as Alexander McQueen, Hussein Chalayan, and Sophie Dahl would not be where they are today if Blow had not discovered and promoted them. And yet some of them forgot what they owed her. Izzy, as her friends called her, felt abandoned. Her hats acquired a new function, as protective shields. They prevented anyone from getting too close. No one would see the depression to which she increasingly fell prey. Seriously ill, she finally succumbed to a suicidal quantity of poison. Even while dying, the petite grande dame of fashion remained true to her eccentricity. In the hospital, she wore scratchy silver lamé from the 1930s. Whether a hat completed her outfit is not known.

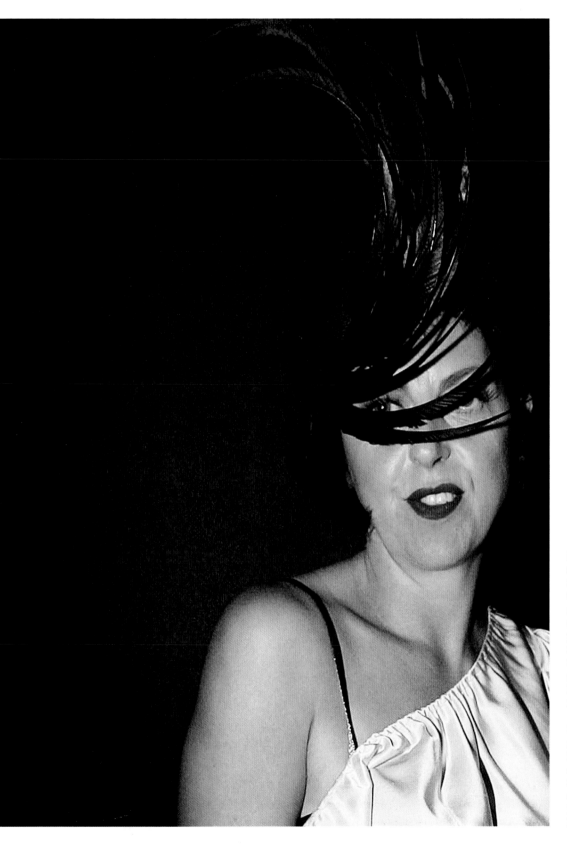

Philip Treacy
and Isabella
Blow attend
the *When Philip
met Isabella*
exhibition
featuring a
range of
hats Treacy
designed for her,
Design Centre,
London, 2002

Isabella Blow
poses at the
launch of
Avolus, a private
transport club,
at Aviva, Hyde
Park Gate,
London, 2005

"You gotta have style. It helps you get up in the morning. It's a way of life. Without it you're nobody. I'm not talking about a lot of clothes."

DIANA VREELAND

"The only real elegance is in the mind. If you've got that, the rest comes from it."

When Diana Vreeland first saw a bikini in 1946—then a novelty—she wryly commented that this piece of clothing was probably the most important invention since the atom bomb. Diana Vreeland obviously took fashion seriously—but never without great wit and a style of her own. As fashion editor for *Harper's Bazaar*, chief editor of *Vogue*, and later curator of the Costume Institute at the Metropolitan Museum of Art, the Paris-born New Yorker not only wrote fashion history for fifty years, but also was herself something of a legend. As far as her appearance was concerned, she was not particularly blessed by nature. And while nature is rarely just, Freeland outwitted it in her own way, getting the very best designers and stylists to provide for her the look that perfectly matched every setting. The fashion legend generally chose sharply tailored, elegant clothing (preferably Chanel or Mainbocher), which she made her own with wild accessories, exotic jewelry, and unusual shoes. Her favorite headwear was opulent silk shawls wound into turbans. Her hair she wore lacquer-black, her high cheekbones were heavily rouged, and her perfectly manicured nails were always signal red. Her most beautiful eccentricity: she never left the house without first having the soles of her shoes polished.

"Never fear being vulgar, just boring."

But she was not only fabulous carrying fashion. Her great gift was writing about fashion and brilliantly dramatizing it. The first commandment: devotion to absolute ostentation. In her legendary "Why don't you?" column, she would tell her readers to wash their blonde daughters' hair with flat champagne, have their monograms stamped on cigarettes, and trim garden hedges into poodle shapes. As chief editor of *Vogue*, she was experimental, inspired, visionary, tyrannical, and extravagant to the tips of her perfectly arranged hair. Nobody discovered (and encouraged) as much talent as she did, and nobody succeeded so well in arousing desires readers never knew they had.

"Without emotion there is no beauty."

One thing is certain—Diana Vreeland left an enormous void in the fashion world. Nobody demonstrated better that elegance and extravagance are not mutually exclusive.

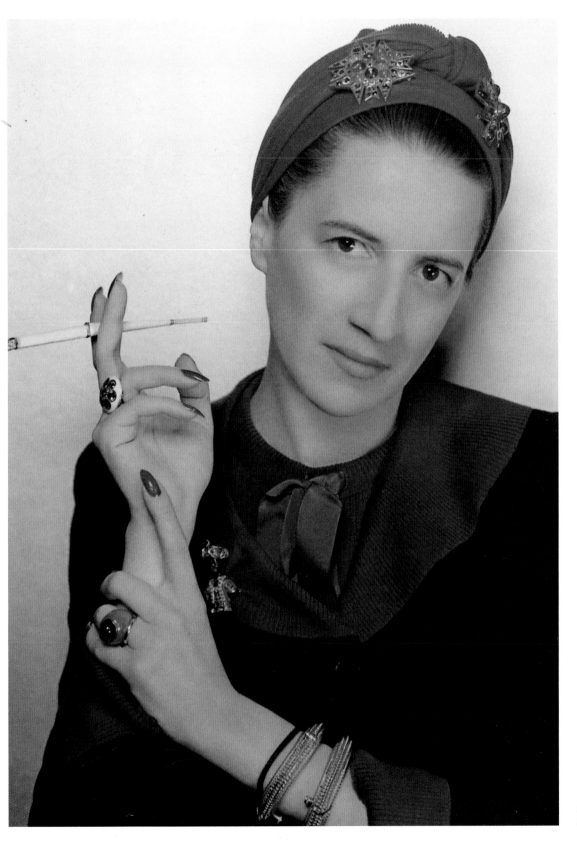

Diana Vreeland,
undated

GRACE JONES

"Once you get to know me, you find I'm quite harmless. I'm not far out at all. Only different."

One would expect a Jamaican-born minister's daughter named Grace to show a hint of softness and amiable modesty—or at least a bit of a laid-back island reserve. With Grace Jones, there's none of that. What you get is a perfectly styled and almost overdone androgynous look that could hardly be topped in hedonism, coolness, and extravagance.

"I wasn't born this way. One creates oneself."

New York's bohemia—including Andy Warhol and Keith Haring—first noticed the tall Jamaican in the seventies when she worked as a model during the day and drifted through New York clubs in men's suits, stilettos, and dramatic makeup at night. With a two-octave vocal range, she soon made the grade as a singer, perfecting her act with the help of French stylist and photographer Jean-Paul Goude. The image he came up with turned her into a fear-inspiring Amazon that exploited every outward definition of gender ad absurdum. The eighties, the decade of exaggerated self-expression, was when her look really reached its pinnacle. Plexiglas bodices, broad collars (often attached to hoods),

skintight bodysuits of stiff fabrics, striking sunglasses, and jackets with extra-wide shoulder pads and exaggerated silhouettes became Jones's trademark. As important as the clothing was her hairstyle (a flattop cut to cut yourself on), her makeup (always dramatic, always dangerous), and her physique, an unnaturally elastic and remarkably muscular form perfectly exhibited in her slick, shiny outfits.

Jones herself believes that her look is thoroughly Jamaican. In Jamaica, she says, women rule: "Just like with lions. The men sleep, the womenfolk catch the prey." And that is just how she looks.

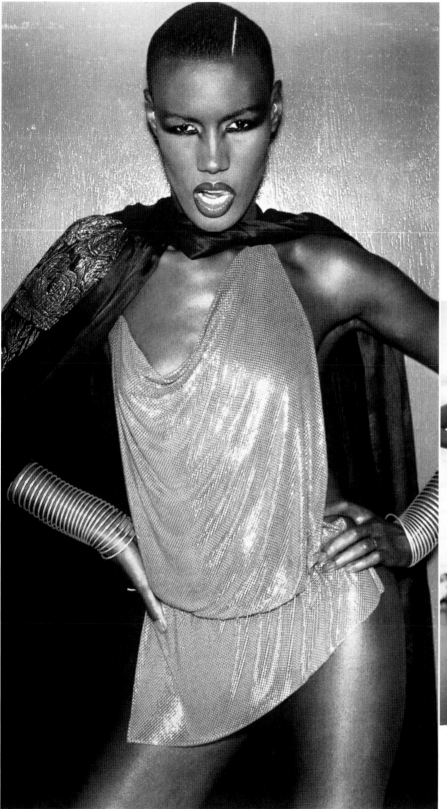

Grace Jones
attending a
Grammy
afterparty,
Los Angeles,
1983

Jones at a fitting
with Azzedine
Alaia, 1985; and
in portrait, 1977

THE CAN

Carrie Bradshaw
Kylie Minogue
Rachel Zoe

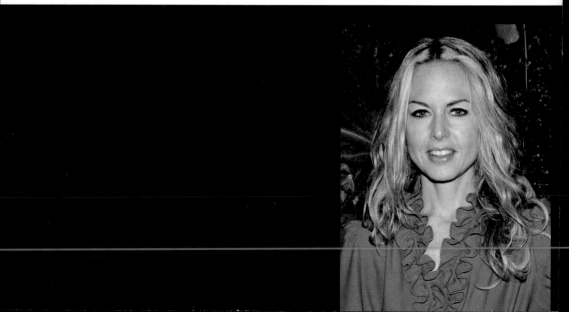

DY GIRLS

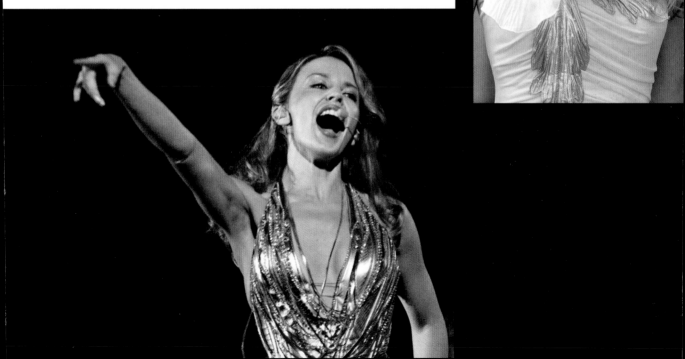

CARRIE BRADSHAW

"When I first moved to New York and I was totally broke, sometimes I'd buy Vogue instead of dinner. I felt it fed me more."

Carrie Bradshaw, a.k.a. fashion revolutionary, global fashion phenomenon, and first style icon of the new millennium. And that despite the fact the New York columnist doesn't really exist. She was born in 1998 on the American television series *Sex and the City*, gestated by actress Sarah Jessica Parker, and dressed with bravura by stylist Patricia Field. The New York costume designer's secret behind Carrie's look: a great appetite for fashion risk.

"A perfect shoe is pure sex on the foot." Sarah Jessica Parker

Carrie's look is unconventional, playful, and designer-heavy—but never perfect. Her outfits are fabulous, in retrospect even fabulously wrong on occasion. But for that very reason, Carrie's style is one thing above all—trend-setting. And yet there's only one constant in her wardrobe: stilettos in all colors, almost always with murderously high heels, and exclusively by Manolo Blahnik. Otherwise Bradshaw has no favorite labels. Though Carrie is in love with designer clothing, she is nonetheless trend-resistant. A colorful mix of haute couture, sales items, and vintage classics is adapted time and again to the individual circumstances of the heroine's life, though not without the occasional fashionable twinkle in her eye. Whether it involves a Fendi fur, a Halston dress, or a vintage cartoon shirt, whatever may come along Carrie preserves her visual attitude and sense of irony. And yet, although the style of the series has been copied a millionfold, and fashion magazines vie with each to devote special sections to Carrie's look, one person steers clear of the fashion star's wardrobe. Although the series has made her a fashion icon, in her private life Sarah Jessica Parker prefers clean, straight lines. For daywear she likes to be casually dressed in jeans, shirts, and plain boots. She admits she never really felt at home with Carrie's delight in experimental dressing. Only on the red carpet does the 5' 4" actress make an exception. Then it's a matter of a stunning gown and especially a pair of Manolos. After all, she owes it to her alter ego.

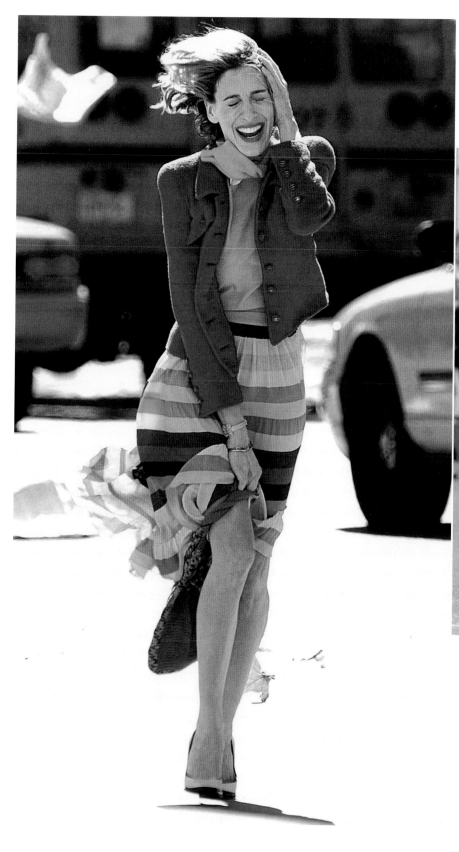

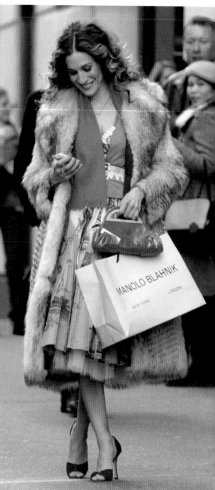

Opposite page, left: Sarah Jessica Parker, aka
Carrie Bradshaw, on the set of *Sex and the
City: The Movie*, New York, 2007; and, above,
on the TV set of *Sex and the City*, New York,
2004

>>
On the set of *Sex and the City: The Movie*,
New York, 2007

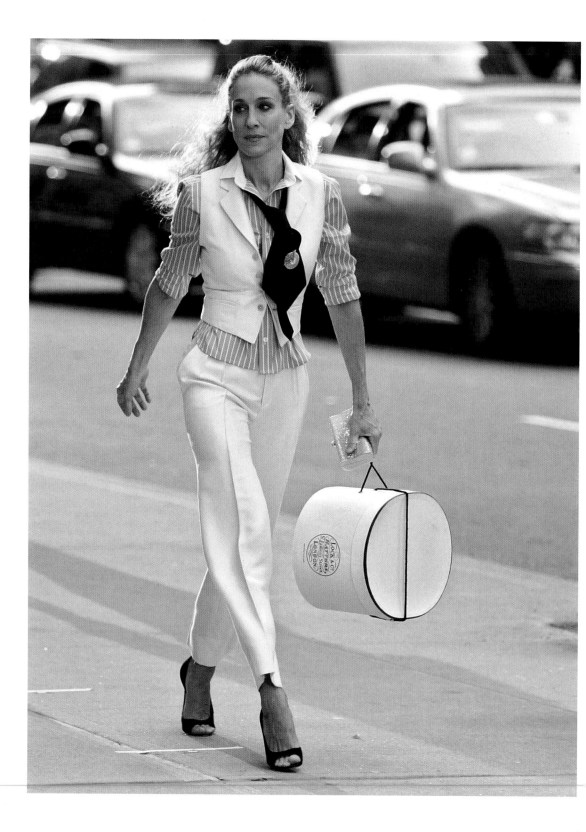

KYLIE MINOGUE

"There's always a moment when I think, ohmigod, am I really wearing hot pants that hardly cover my backside?"

Some things never change. Once there was a girl at school who was so beautiful and marvelously dressed that every boy wanted to go out with her, and every girl not only wanted the most beautiful girl in the class as their best friend but would have really loved to have had the key to her closet. Kylie Minogue is still a girl like that. Or rather, that's what she became at the age of thirty-two.

In 2000, the singer published her comeback single *Spinning Around*. Things had been rather quiet at the time, and it was not as if she had gotten headlines as a snappy dresser anyway. The disc sold quite well, but the accompanying video got the whole world talking. In it Kylie wore a pair of golden hot pants that were so short you could hardly take your eyes off of them. Thanks to these hot pants an assistant bought in a London second-hand store for 75 pence, Minogue was back in the news—and without planning it, had at last found her style.

Even now, the graceful Australian's looks function along the lines of a really good pop song: they're fresh, uncomplicated, and super sexy. However, the most impressive thing about her outfits—often transparent or scanty garments, frequently in white or very bright colors—is the way she wears them. The naked skin is never without a compensatory sugar-sweet smile, and Minogue trots around on sky-high heels with more assurance than others go barefoot. Although she hardly ever sings about sex, she looks as if she could teach you all you wanted to know about it and still tell a good joke. She pulls off this rare balancing act because she treats both herself and her outfits—even during lean times—with a healthy dose of irony. No wonder that most people would still choose Kylie as the prom queen.

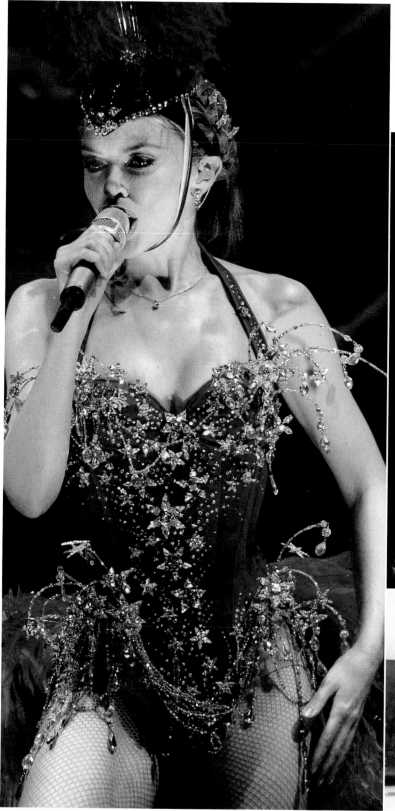

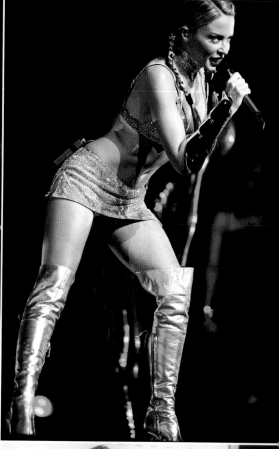

Kylie Minogue on stage during her "Showgirl" tour, Glasgow, 2005; in the video for *Spinning Around*, 2000; and performing in concert at the start of her "Fever" tour, Cardiff International Arena, 2002

RACHEL ZOE

"You're only here once. Why shouldn't you do it with style?"

It's true that young Hollywood is starting to look a bit conformist—an ultra-slim figure combined with a style somewhere between Californian casual and New York cool. But the standard "pretty look" of stars and starlets is no accident. There is usually the same person behind every outfit—Rachel Zoe, probably the most successful stylist in Hollywood if not the world. Although she didn't invent the profession, she managed to raise it to a completely new level. Her influence on things fashion has long gone beyond the confines of show business.

"I think people should look cute all the time."

Once—i. e. before Rachel Zoe—it was a stylist's job to dress stars for a glamorous appearance on the red carpet and decide about hairstyle and makeup. For Zoe, that isn't enough. The girls she dresses are always pretty and everywhere—and always photogenic. Because the right outfit, especially while "off duty," fills the fashion pages of countless celebrity magazines throughout the world and consequently enhances the market value of those featured. Zoe's clientele includes, among others, Nicole Richie, Keira Knightley, Lindsay Lohan, Cameron Diaz, and Mischa Barton, who thanks to her fashion sense regularly top the best-dressed lists worldwide.

Yet the dainty blond, whose daily fee is $6,000, has a very simple procedure: she simply adapts her clients to her own style. Outsized sunglasses, an up-to-the-minute, sinfully expensive It bag, tons of gold bling, a heavily tanned complexion, and a hairdo carefully cut to look careless are the foundations of almost every look she has created. Her seventies-inspired outfits are always a tad ostentatious and theatrical, yet always rather cute as well. Insouciant though the looks may seem, Rachel Zoe firmly holds the reins. Popularity, fame, and fashion come together in a commercially and extremely lucrative mix. She is a little hurt that her clients are mockingly branded as "Zoebots." They are after all pretty to look at, every time. And for Rachel Zoe, that is ultimately what it's all about.

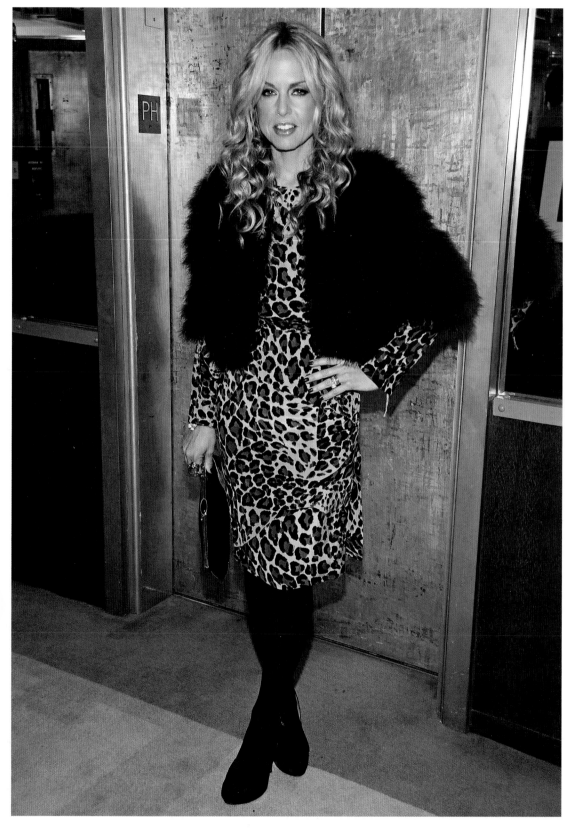

Rachel Zoe
attends a
fashion event,
Watermill, NY,
2007

Attending
a party,
New York, 2006

THE

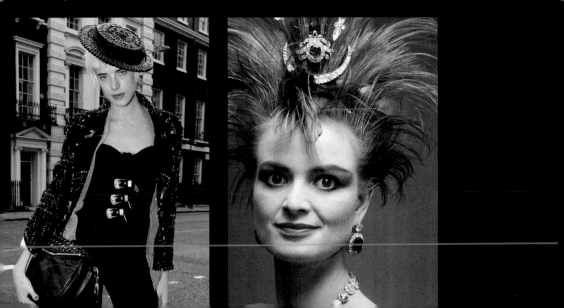

REBELS

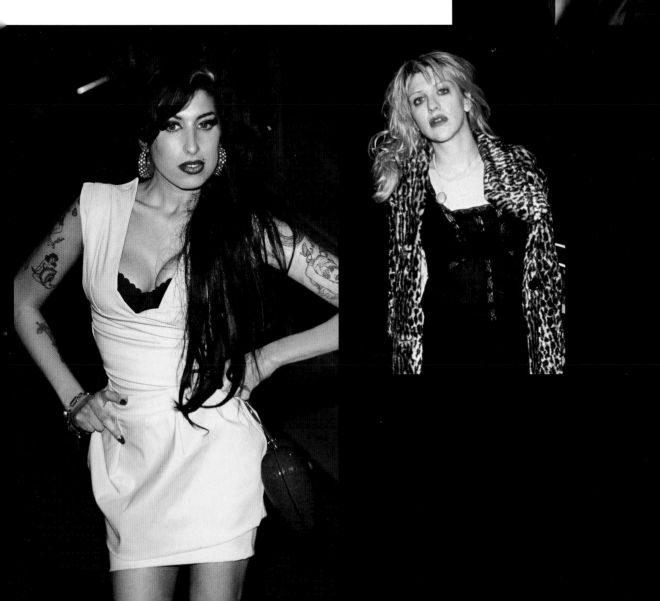

AGYNESS DEYN

"I don't really go to fashion parties; they're not my scene."

Agyness Deyn's unspectacular real name is Laura Hollins. Though she now lives in New York (in the East Village), she grew up in Stubbins, an unremarkable industrial village in Lancashire. But that's not important. Agyness (pronounced Agnes) easily made the leap from backwoods Lancastrian to cosmopolitan super-model. And that's despite at first glance hardly looking the part for the glamorous world of the catwalk.

"When I started, I was very boyish-punkish. Now I think I've gone a bit lady punk."

The thing is, Aggy, as she is affectionately known in the English press, not only wears her hair rather short, but rather too bleach-blonde for a commercial supermodel. She prefers to cycle to fashion shows rather than using the limo service. She steers clear of fashion parties, and prefers to down her beer in dodgy dive bars. Instead of couture, she prefers a look inspired by the street style of London, where there are no rules. Deyn's fashion experiments are idiosyncratic combinations that cut across her entire wardrobe. The result is generally eclectic, edgy, and androgynous—and rarely beautiful in the conventional sense. She does not seem overly impressed with the fashion world, which most of the time takes itself much too seriously. But it has taken a shine to the uncomplicated fashion rebel. Anna Wintour, the influential chief editor of US *Vogue*, praises Deyn's good-humored punk style as "refreshingly uncompromising." The fashion magazine *i-D*, the über-magazine for style enthusiasts,

devoted an entire issue to her in May 2008, a singular occurrence in the magazine's twenty-eight-year history. Star photographer Mario Testino gushes about how moved he is by "this British girl."

But what does Agyness make of all the praise? She remains just as she was—unimpressed. And undoubtedly a step ahead of the rest.

Agyness Deyn
on the set of a
music video,
New York, 2008;
and attending
a fashion party,
London, 2007

GLORIA VON THURN UND TAXIS

"She is Princess TNT, the dynamite socialite." Vanity Fair

Noblesse oblige? No way! In the 1980s, Gloria von Thurn und Taxis was the enfant terrible of high society—etiquette and pearl necklaces meant nothing to the young aristocrat as she partied with the international jet set. Besides raising her three children, Gloria saw her main duty as socializing with rock stars. For that, one needs a style that attracts attention—brash outfits and star stylist Gerhardt Meir's brightly colored punk hairstyles became the trademark of the high-living pop aristocrat. Gloria was the highly visible spirit of the eighties as her controversial style combined a champagne-glamour look with custom punk accessories. The tabloids—where she was both praised and skewered—quickly found a suitable nickname for her: "Princess TNT."

Gloria marked the climax of her wild period with a multi-million-dollar masquerade bacchanal to celebrate her husband's birthday (he was thirty-eight years her senior) that was shunned by the European aristocracy. Guests such as Mick Jagger and Jerry Hall—in befitting rococo costume including powdered wigs—were nonetheless quite happy to join in on the celebration.

At first glance, Gloria seems to have had the Marchesa Casati as her inspiration. But the marchesa actually followed her lifestyle to its logical conclusion. For Gloria the party suddenly ended with her husband's death in 1990. She changed her life and her look radically, adopting a conservative suit and pageboy hair-style. Now safely back in the ranks of the aristocracy, the Bavarian princess is even writing a book about the etiquette she once despised, and has dismissed her past as just a "fancy dress phase." There's not a trace of it left, in fact. A pity, really.

Princess Gloria
von Thurn und
Taxis, New York,
1987

COURTNEY LOVE

"Being famous is just like being in high school. But I'm not interested in being the cheerleader. I'm out in the smoker shed."

Once asked how she sees herself, Courtney Love said as a force of nature. That was not entirely off base. Or at least that is how the musician came across—furious, ravaged, and unique.

A moderately well-known singer when she married Nirvana front man and grunge god Kurt Cobain in 1992, Love suddenly found herself in the limelight. But it was not her music that attracted most of the attention, but her style that the media could not get enough of—with smeared scarlet lipstick, ruinously bleached hair, diadem, and transparent sprig dress, she played the part of a common slut. And yet in reality she came across more like someone done up as a helpless victim of domestic violence.

Love's pathetic but defiant look had a basis in reality. Her father described his greatest achievement as having given her LSD as a child. A stripper at fourteen, only the places she danced were exotic: Japan, Taiwan, and Alaska. And yet, despite—or perhaps because of—her biography, her frequently erratic public behavior, and her non-conformist anti-look, no one had a greater influence on the female grunge style than Love.

In 1994, after two years of marriage, Cobain committed suicide and grunge slowly followed him into oblivion. Love changed course and turned to couture rather than drugs. Her appearance at the 1997 Oscar awards heralded her fashion metamorphosis. She was the very image of a thespian strolling across the red carpet in radiant white Versace with soft make-up and a perfectly cut bob. She almost looked polished. In the end, she just couldn't pull it off. Even today, Courtney Love still looks a little disreputable; she may blow-dry her hair more often, but the peroxide blonde is still there. A force of nature is not so easily tamed.

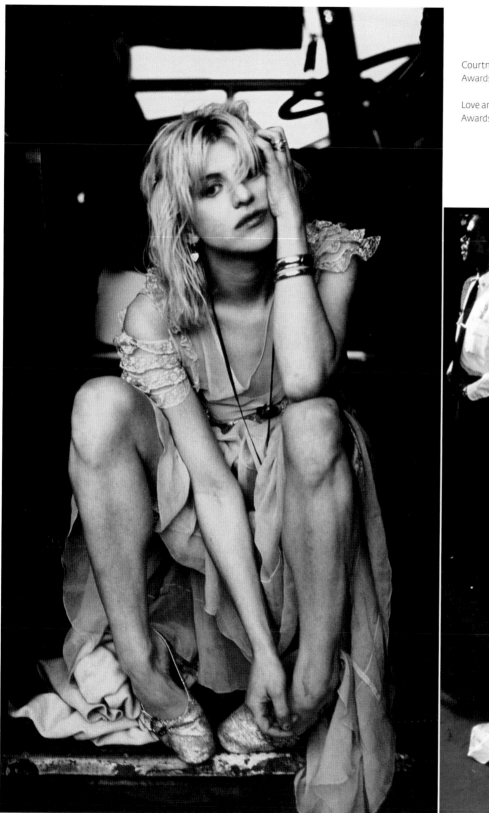

Courtney Love at the MTV Video Music Awards, New York, 1995

Love arriving at the 69th Annual Academy Awards, Hollywood, 1997; and in 1993

VIVIENNE WESTWOOD

"I have an inner clock that calls time on everything orthodox."

Anyone who believes that the fashions of the seventies were created exclusively on the dance floor of Studio 54 should take a look at Great Britain. What was happening there was anything but a non-stop disco. Soulless housing estates, recession, unemployment, and poor education guaranteed a mood that had nothing at all in common with the peaceful hippy vibe or the sequined glamour of disco freaks. Truculence, violence, and disaffection were what characterized the bored, written-off young underclass. Their attitude came from the streets—and their clothes from Vivienne Westwood, mother of all punks.

Westwood was actually a primary school teacher, but her creativity and delight in the far-out drove her in an entirely different direction. In the early seventies, she and the later Sex Pistols manager Malcolm McLaren opened a boutique in London's Kings Road called (after several name changes) SEX and later Seditionaires, where they sold fashions geared toward their own ramshackle style. Along with bondage and fetish wear, they sold all kinds of clothes they had torn apart and refashioned (the materials included feathers, zips, safety pins, rivets, chains, and chicken bones) and shirts with offensive slogans. This not only attracted attention but also formed the foundation of the punk style. Westwood wanted to challenge taboos about sexuality, tradition, and society in a visually provocative manner. The authorities responded with arrests and store raids, which in turn did wonders for her street credibility and ultimately led to her international breakthrough.

In the late seventies something that eventually affects any influential avant-garde movement happened—the mainstream discovered punk and its subversive aura went up in smoke. Vivienne Westwood's response was to turn the punk street look she helped develop into more and more complex creations, and since the mid-eighties has shown them during Paris fashion week. The trademarks of the new Westwood look are historical styling, exaggerated lines, and an old-new reinterpreted femininity with corsets and crinolines that makes women not objects of desire but powerful sexual creatures.

Although the grande dame of British fashion has gone bourgeois, a touch of the punk still lurks within. The self-taught fashion designer not only forsook panties to visit the Queen, but also keeps her business independent as a strike against the capitalization and commercialization of the fashion industry. Only if you're free can you thumb your nose at convention.

"Punk is part of my history. I thought there's a door you have to open. Now I know there really isn't. There are just hoops you have to jump through."

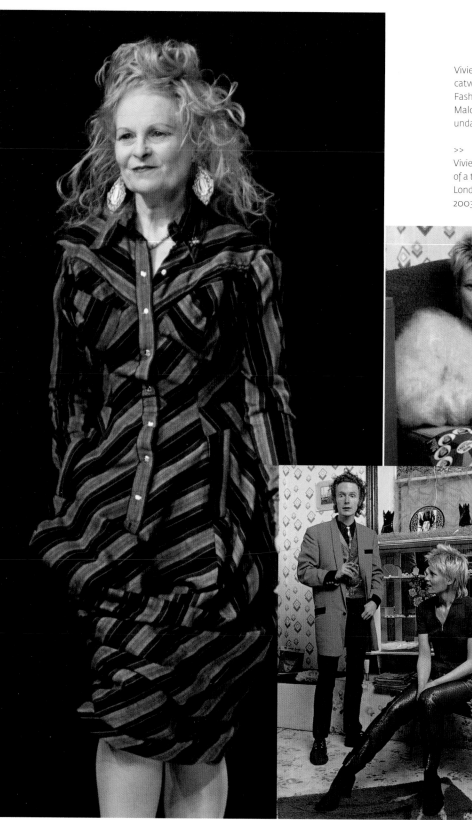

Vivienne Westwood walks down the catwalk at her fashion show during Paris Fashion Week, 2008; and posing (with Malcom McLaren, top) at Let it Rock, undated

>>
Vivienne Westwood (right) standing in front of a telephone box with other punk girls on a London street, 1977; and in portrait, London, 2003

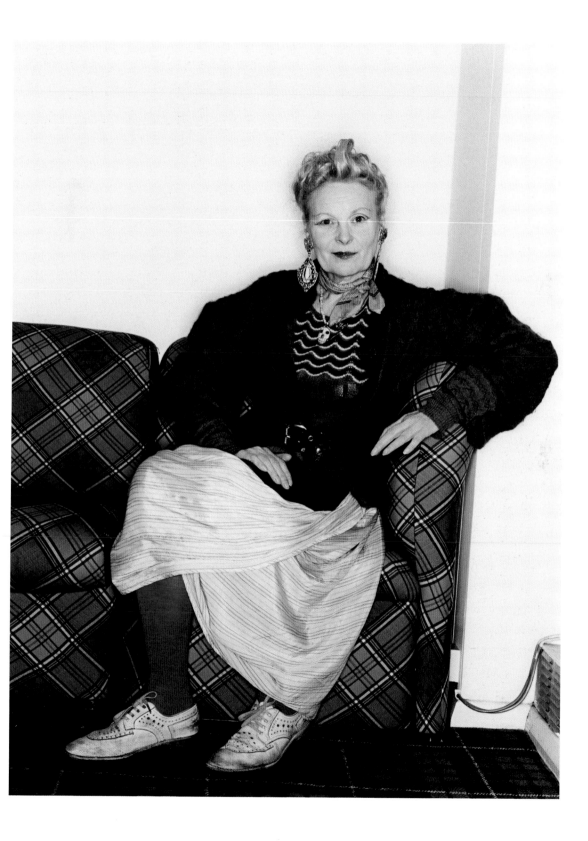

AMY WINEHOUSE

"She's a beautiful, talented artiste. And I really like her hairdo. I get inspiration from it." Karl Lagerfeld

When she performs, alcohol must always be within reach. If fans act stupidly, she lashes out. And if she doesn't feel well, she's either sick on stage or cancels her concerts at the last minute. One thing is clear—Amy Winehouse is anything but a watered-down pop princess. A highly talented soul singer, she prefers to follow the lead of her male rock star colleagues. She has a reputation as a drinker and consumer of hard drugs, and supposedly suffers from an eating disorder. Even in the traditionally murky British music scene, she stands out as a real original—and not least because of her appearance.

The scandal-ridden Londoner is anything but a passive clotheshorse. Her look—a wild yet feminine mixture of sixties chic, rockabilly details, and grunge revival—has become the petite 5' 3" singer's trademark. Her most conspicuous feature is her hairdo, a piled-high, tousled beehive dyed pitch black, which Winehouse wears either by itself or with a scarf wrapped around it. She accentuates her eyes with curved eyeliner nearly half an inch thick, while her usually sickly-pale skin serves as a canvas for any number of tattoos, including two fifties pinup girls named Gabrielle and Cynthia, horseshoes, hearts, and, above her left breast, her husband's name.

For Winehouse, a typical outfit includes close-fitting polo shirts and vests (often with a colored bra showing through) matched with drainpipe jeans and pink ballet shoes, or, for official appearances and concerts, pencil skirts and short cocktail dresses with high heels. Regardless of whether it's on stage, at night on the streets of Camden, or at one of her recurring court dates, Winehouse remains true to herself and her style in every situation. Healthy it's not—but it gives her credibility.

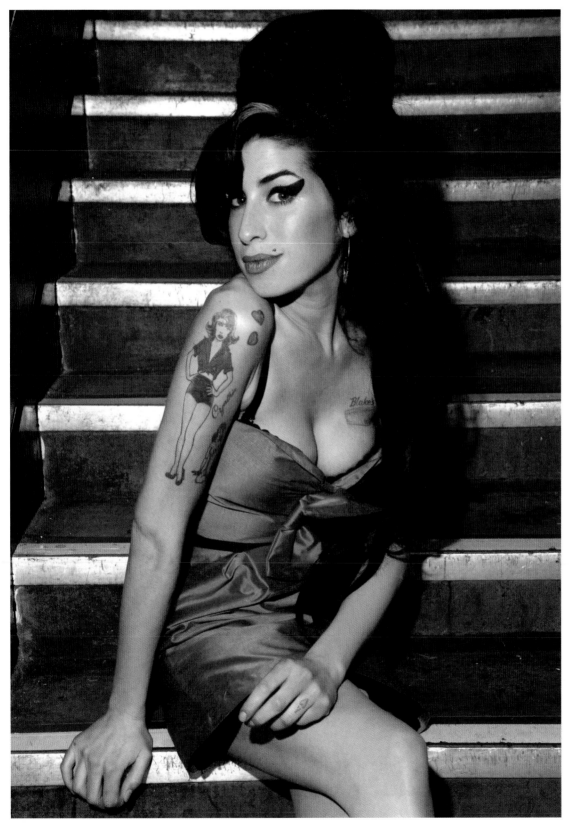

Amy
Winehouse,
London, 2007

THE CHA

Madonna

MELEON

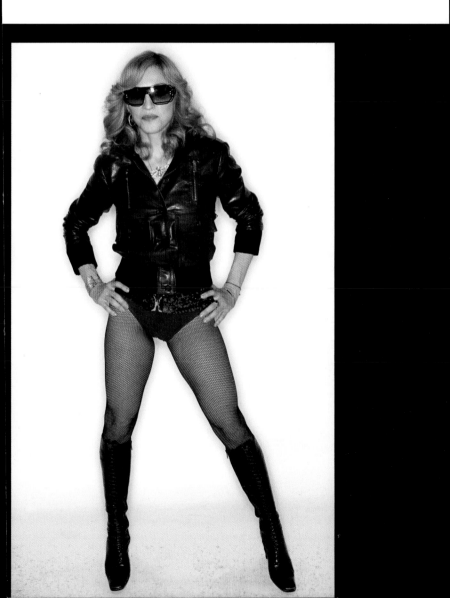

MADONNA

"I am my own experiment. I am my own work of art."

She is the megastar of pop. It would be hard finding someone in the world who doesn't know Madonna. Or rather, thinks they know her. Because Madonna Louise Veronica Ciccone is not only queen of the dance floor, but first and foremost a virtuoso of self-production. Madonna reinvents herself and her look with every new album—and almost incidentally marks the trend in music and fashion. Yet her function as a global fashion barometer is anything but an accident. No one knows better than Madonna how to make the spirit of tomorrow her own style today.

The once middle-class girl had her breakthrough in 1983 with *Holiday*. It was mainly her trash look that caused a stir. She was the first to combine aggressive post-punk with girlish New Romantic elements. Her combinations of white lace, greasy leather, costume jewelry, fingerless gloves, and untidy hair hit a nerve at the time. Madonna sold not only records but an attitude as well. In the early nineties, she had the guardians of morality gasping again—her new, more severe, fetish-inspired style shocked and fascinated the world in equal measure. The legendary corset with the cone-bra designed by Jean-Paul Gaultier was the perfect answer to the cyberspace age. But Madonna would not be Madonna if she hadn't immediately come up with a counter-reaction to the New Economy. Eight years later, her Far East-inspired look with long hair, prayer rings, and henna tattoos became the most important trend of an already hectic turn of the millennium.

Whether seen as a trash diva, cyber-dominatrix, or spiritual guru—or any of the innumerable other (successful) transforma-tions of style in between—the question still remains as to who Madonna the person really is. Of course, there is no answer. Perhaps because the real Madonna is indeed only a phenomenon of the moment, the projection of a global trend. But in contrast to her imitators, she doesn't just wear her looks—she lives them as well. At least until the next mutation.

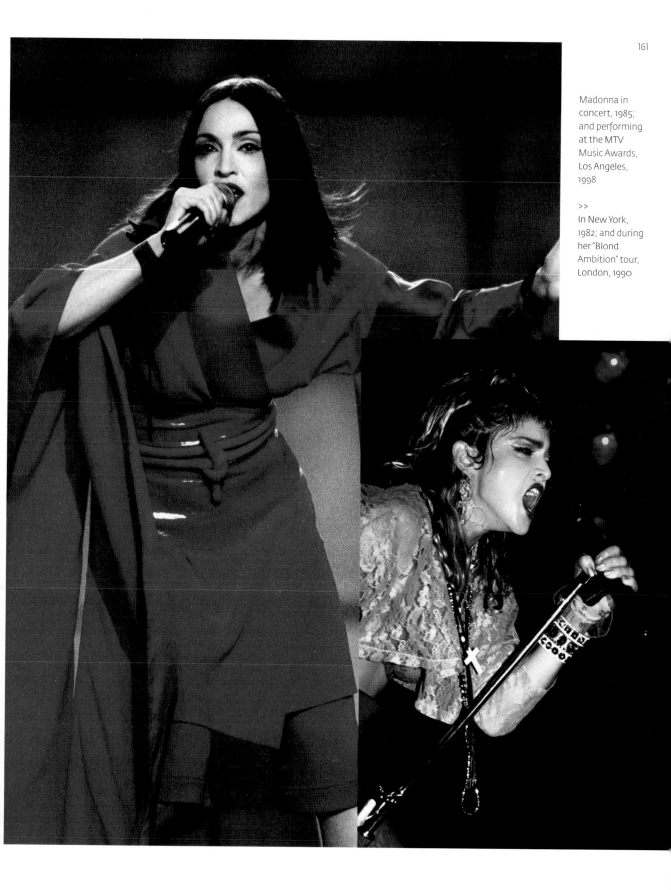

Madonna in
concert, 1985;
and performing
at the MTV
Music Awards,
Los Angeles,
1998

>>
In New York,
1982; and during
her "Blond
Ambition" tour,
London, 1990

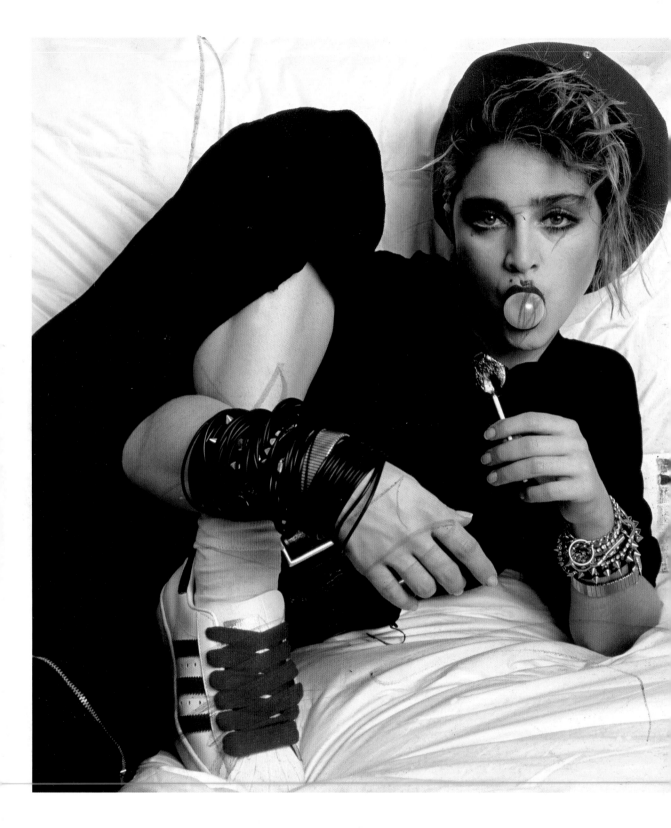

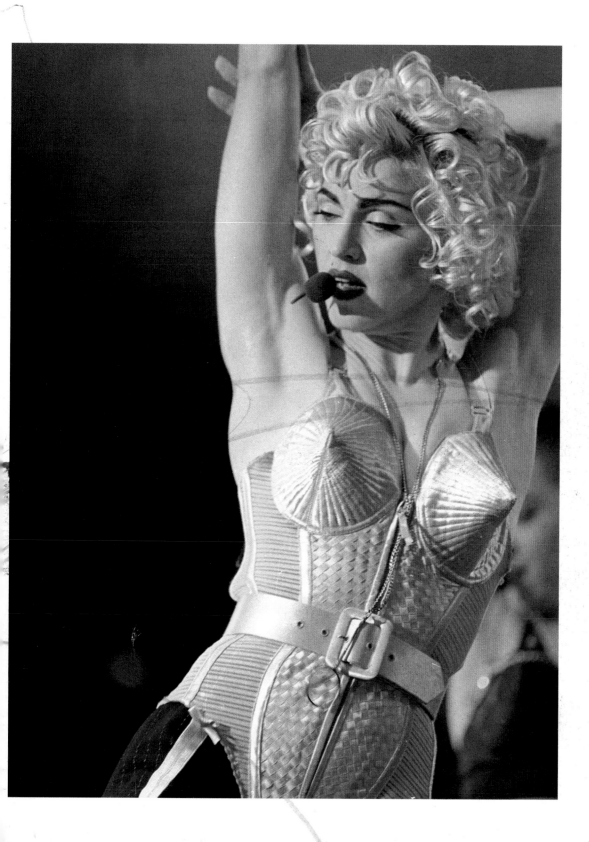

BIOG

RAPHIES

JOSEPHINE BAKER Born in impoverished circumstances in St. Louis, Missouri in 1906, died in Paris in 1975. A chorus dancer, vaudeville and film actress, and singer, she did much to popularize jazz and the Charleston worldwide. She assisted the French Underground and Resistance during World War II, and supported the American Civil Rights movement in the fifties, adopting twelve children of different races.

BRIGITTE BARDOT Born 1934 in Paris, she started out modeling hats, but was soon discovered by the film industry. She was active as a singer and film actress from 1952 to 1973, after which she retired from film completely. Now known for her dedication to animal rights, she has been married four times, and has become an increasingly controversial figure because of her non-politically correct statements.

CAROLYN BESSETTE KENNEDY Born 1966 in New York, died 1999 off the coast of Massachusetts. Before her marriage, she worked as a PR consultant for Calvin Klein and others. In 1996, she married President Kennedy's son John F. Kennedy Jr., and the couple became the new glamour item in New York society. Carolyn Bessette, her sister, and her husband were killed when the plane he was piloting crashed into the sea.

BJÖRK Born Björk Gudmundsdóttir in Reykjavík in 1965. A singer, composer, and songwriter, she published her first album—a compilation of Icelandic children's songs—at the age of eleven. She is interested in a wide range of musical styles, reflected in her later albums. The mother of two children, she is also an actress.

ISABELLA BLOW Born 1958 in London, she died there in 2007 following self-inflicted poisoning. A fashion journalist and former assistant to Anna Wintour, she had an infallible eye for new talent, which she continually encouraged. Isabella Blow suffered from severe depression, and felt that the fashion world had left her in the lurch.

CARRIE BRADSHAW is the lead character in the US TV series *Sex and the City* (1998–2004) and the film of the same name (2008). The fictional character worked as a columnist and later author in New York.

LOUISE BROOKS Born 1906 in Cherryvale, Kansas, died 1985 in Rochester, New York. She was best known for her part in G. W. Pabst's film *Pandora's Box*, which caused a stir with its scenes of explicit lesbianism. Brooks's outré choice of roles and her fast lifestyle meant Hollywood soon turned against her. Her reputation was rehabilitated in the fifties, thanks to French film historians.

LUISA CASATI STAMPA DI SONCINO, MARCHESA DI ROMA Born 1881 in Milan, died 1957 in London. She was a muse, patroness of the arts, socialite, and one of Europe's richest heiresses. Though married, she had numerous affairs. In 1930, up to her ears in debt, she fled to London, living out the rest of her days there in poverty.

GABRIELLE "COCO" CHANEL Born 1883 in Saumur, France, died 1971 in Paris. After a stint at a Paris tailor, she began designing hats in 1910. By 1913 she had opened her first shop, where she sold fashionable outdoor wear. When World War II broke out, she closed her shops and retired from the fashion world. She returned to Paris and the fashion world in 1954, at the age of 71. Coco Chanel is considered the most influential fashion designer of the twentieth century.

SOFIA COPPOLA Born 1971 in New York. She studied painting and photography, and initially made a living as a fashion designer before following her father Francis Ford Coppola into film directing. Her feature film debut was *The Virgin Suicides*, and four years later she won an Oscar with *Lost in Translation*. Sofia Coppola lives in Paris.

JOAN CRAWFORD Born Lucille Fay LeSueur in San Antonio, Texas, probably in 1905, died 1977 in New York. She was active in films from the silent era to the seventies. Her public image after her death was largely negative as a result of her adopted daughter's autobiographical

memoir *Mommie Dearest*. These days, her reputation as a film actress these days is ambiguous.

AGYNESS DEYN Born Laura Hollins in Lancashire in 1983. Before becoming a model, she studied drama and music. She is the muse of designer Christopher Bailey (Burberry) and the face of numerous advertising campaigns. Besides working as a model, she is an active DJ and musician.

MARLENE DIETRICH Born 1901 in Berlin, died in Paris on May 6, 1992. She studied the violin at school, but in the twenties worked as a film and stage actress. Her breakthrough role was in UFA's *Blue Angel* (1930). With the film's success, she moved with its director, Joseph von Sternberg, to Hollywood. She was an active opponent of the Nazi regime in Germany and gained awards for her war work. In 1975, she retired from public life, living in Paris.

C. Z. GUEST Born Lucille Douglas Cochrane in Boston in 1920, died on November 8, 2003 in New York. Following a serious riding accident, she took up gardening in a big way, and began a gardening column for the *New York Post*, which was eventually syndicated in over 350 papers.

GLORIA GUINNESS Born Gloria Rubio y Alatorre in Mexico in 1912, died 1980 in Lausanne, Switzerland. A socialite and fashion journalist, Guinness is the subject of several legends, among them were that she worked as a spy during World War II, and that she was stateless until she married her fourth and final husband Group Captain Loel Guinness.

AUDREY HEPBURN Born 1929 in Brussels, died 1993 in Tolochenaz, near Lausanne, Switzerland. In 1948 she went to London to continue her ballet training with Marie Rambert. After playing in several British films, she earned a leading role in *Gigi* on Broadway. Her first American film was *Roman Holiday*. In the late sixties, she virtually gave up acting to do humanitarian work for Africa, from 1988 working for UNICEF in Africa, South America, and Asia.

KATHERINE HEPBURN Born 1907 in Hartford, Connecticut, died 2003 in Old Saybrook, Connecticut. The daughter of a surgeon and a women's rights activist, she graduated college with a degree in philosophy and history before becoming an actress. Hepburn liked roles featuring strong, independent-minded women. Her acting achievements earned her four Oscars. Her long-time partner was actor Spencer Tracy.

CAROLINA HERRERA Born 1939 in Caracas, Venezuela, she grew up in a well-to-do landowning family. Has designed fashions and created perfumes since the eighties, and runs her New York-based company herself. Prior to that, she won international recognition dressing Jacqueline Kennedy Onassis. She has married twice, and has four children.

BIANCA JAGGER Born 1950 in Managua, Nicaragua. She is famous mainly for her disco-dancing days and marriage to Rolling Stone Mick Jagger in the early seventies. After they divorced in 1979, the former photo model became a human rights activist, and in 2004 she was awarded the Right Livelihood Award. Bianca Jagger still lives in New York.

SCARLETT JOHANSSON Born 1984 in New York. She first hit the headlines with a film role in *The Horse Whisperer* in 1998, though her international breakthrough came with *Lost in Translation* in 2003, for which she won a Best Actress prize at the Venice Film Festival. Since 2007, Johansson has been a global ambassador for the relief and development agency Oxfam.

GRACE JONES Born 1948 in Jamaica, the daughter of a clergyman. In 1965, the family moved to New York, where she became a photographer's model. After a successful period in the fashion business, she switched careers and became a singer. Her consciously androgynous look made her an icon of the gay disco movement. In 1985, she appeared in the Bond movie *A View to Kill*, followed by other film roles and a comeback album in the new millennium. She lives in London.

QUEEN RANIA OF JORDAN Born a commoner in 1970, the daughter of a Jordanian family of Palestinian extraction in Kuwait. After studying economics at the American University in Cairo, in 1993 she married Prince Abdullah of Jordan, crowned king in 1999. The mother of four children, she focuses particularly on social, welfare, and medical issues relating to women and children.

FRIDA KAHLO Born 1907 in Coyoacán, Mexico, she died there in 1954. She became a painter after sustaining a horrific injury in a bus accident, which would plague her the rest of her life. Her pictures—largely in the tradition of Mexican folk art and modernism—mainly deal with her life and personal circumstances. Kahlo had an off-and-on marriage with artist Diego Rivera.

NANCY (SLIM) GROSS HAWKS HAYWARD KEITH, LADY KEITH Born 1916 in Salinas, California, died of lung cancer in New York in 1990. Married three times, socialite Slim Keith was a permanent fixture in U. S. high society in the fifties and sixties. She broke with Truman Capote following his unflattering portrait of her in his novel *Answered Prayers*.

GRACE PATRICIA KELLY (PRINCESS GRACE OF MONACO) Born 1929 in Philadelphia, died 1982 in Monte Carlo following an unexplained car accident. A very successful film star, she married Prince Rainier III in 1956, thereby becoming princess consort of Monaco. Children from the marriage are Caroline, Albert, and Stéphanie.

JACQUELINE KENNEDY ONASSIS Born 1929 in New York, she died there in 1994. She studied history, literature, art, and French in the U. S. and France. She made the acquaintance of her later husband, U. S. president John F. Kennedy, during an interview while she was working as a journalist. When he was assassinated in 1963, she and her two children retired from public life. Five years later, she married shipping magnate Aristotle Onassis. After he died, she returned to work as a book editor.

SUZANNE LENGLEN Born 1899 in Compiègne, France, died of leukemia in Paris in 1938. She is considered one of the best tennis players of all time, and the sport's first star. Between 1919 and 1926 she won 31 grand slam titles. She suffered her entire life from chronic asthma.

COURTNEY LOVE Born 1964 in San Francisco, California. Her childhood was scarred by spells in homes and correctional institutions. In early adulthood, she scraped together a living with odd jobs and as a stripper. Later she founded the punk rock band Hole, and in 1992 married Nirvana singer Kurt Cobain, by whom she had a daughter. Love now works as an actress, but her behavior makes her a controversial figure constantly at odds with the law.

MADONNA Born Madonna Louise Ciccone in Bay City, Michigan, in 1958. Her childhood was marked by the premature death of her mother. Her early training and career was in dance. However, she hit the big time with her records; her album *Like a Virgin* sold 12 million copies worldwide. Her music videos have made her changing visual styles very influential. She has also successfully appeared in various films. Occasional public controversies have done her career no harm over three decades.

SIENNA MILLER Born in New York on December 28, 1981, but grew up in England. She worked as a model before becoming an actress, mostly in films. She appears in the press mostly for her personal relationships with actors. She and her sister Savannah, a professional designer, produce designs for a fashion label called Twenty8Twelve, named so for her date of birth.

KYLIE MINOGUE Born 1968 in Melbourne, Australia. She became known as a character in the eighties' soap *Neighbours* and as a pop starlet with hits such as "I Should Be So Lucky." The success of the latter prompted her to switch to music full-time. Her change of image from harmless girl to vamp frightened off

most of her fans, and she did not successfully re-establish herself until 2000. Now resident in London, she was diagnosed with breast cancer in 2005, but has had effective treatment for it.

MARILYN MONROE Born Norma Jeane Mortensen (but baptized Baker) in 1926 in Los Angeles, California, she died there of a barbiturate overdose in 1962. She spent much of her childhood in numerous foster homes. After World War II, she became a photographer's model, then from the late forties a film actress, singing in some of her roles. She is best known as the first international sex symbol film star. She married three times and had numerous affairs, including briefly with President Kennedy. Stage fright and psychological problems led to dependency on medications and alcohol. The circumstances of her death—whether an accident, suicide, or murder—remain unclear to this day.

KATE MOSS Born 1974 in Croydon, London. She was discovered at 14, and had her breakthrough with the Calvin Klein campaign "Heroin Kids," which triggered off an international controversy over anorexic models. Moss's private life has frequently been in the headlines for her recreational drug use and sentimental relationships. She is nonetheless one of the most successful models in the world. She lives with her daughter in London.

BARBARA CUSHING (BABE PALEY) Born July 5, 1915 in Baltimore, Maryland, died of lung cancer in New York on July 6, 1978. After a short-lived marriage to American oil heir Stanley Grafton Mortimer Jr., she married William S. Paley, founder of the CBS television station. She was a fashion editor at *Vogue* and a fixture in American high society. She made her name above all as a legendary hostess of perfectly planned society functions.

SARAH JESSICA PARKER Born 1965 in Nelsonville, Ohio, grew up in a family of eight children. She was already a performer as a child, acting on Broadway at age eleven. Her most important role was as sex columnist Carrie Bradshaw in the TV series *Sex and the City*, for which she won four Golden Globes. She and husband Matthew Broderick have one son.

ANNA PIAGGI Born in Milan, probably in 1931. She is best known for her montages with Luca Stoppini for Italian *Vogue* and her avant-garde magazine *Vanity*. Since 1969, she has written her texts on the same bright red Olivetti typewriter. In 2006, the Victoria & Albert Museum in London mounted an exhibition about her. Anna Piaggi lives in New York, London, and Italy.

MARY QUANT Born in Blackheath, London on February 11, 1934. In 1955, she and husband Alexander Plunkett-Greene opened a shop called Bazaar on London's King's Road, Chelsea. Her best-known creation is the miniskirt, which was first featured in *Vogue* in 1962. In 1966, she was awarded an OBE. She resigned from her company in 2000, after a Japanese takeover.

JIL SANDER Born Heidemarie Jiline Sander in Wesselburen, Germany, in 1943. Sander is a distinguished minimalist fashion designer of international repute. After studying textile design and working as a fashion editor, she opened her first boutique in Hamburg in 1967. Her international breakthrough with her cosmetics and fashions came in the late seventies. She left her own company in 2000 over differences with new owner Prada. She lives with her partner in Hamburg.

EDITH (EDIE) MINTRUM SEDGWICK Born April 20, 1943 in Santa Barbara, California, she died there on November 15, 1971. A party girl from a well-off background, she worked for a time as an actress and model in New York. She was briefly a muse and associate of Andy Warhol, who made the film *Poor Little Rich Girl* with her. She was anorexic and suffered from eating disorders. She died of an overdose of barbiturates.

CHLOË SEVIGNY Born in Darien, Connecticut, in 1974. She left home at 18, acquiring an apartment in Brooklyn. Her debut as a film actress came in the indie film *Kids* in 1995, which was followed by roles in other independent films. She became well known with her nominations for Best Supporting Actress for *Boys Don't Cry* (1999).

ELSA SCHIAPARELLI Born in Rome in 1890, died in Paris in 1973. Her designs were strongly influenced by Dada and Surrealism. In the late thirties, she introduced zippers to haute couture, and was one of the first fashion designers to provide accessories for her clothes. One new idea she introduced was the one-bare-shoulder look. Schiaparelli retired from the fashion business in 1952.

LADY DIANA SPENCER, PRINCESS OF WALES Born in Sandringham, Norfolk, in 1961, died in Paris in 1997. She married Charles, Prince of Wales, in 1981, by whom she had two children, William and Harry. Thereafter she was never out of the media spotlight, which she skillfully exploited for her own ends, including her role as ambassador for the Red Cross and her anti-land mine campaign. She died in a road accident, triggering off an unprece-dented outpouring of media sentimentality.

GWEN RENÉE STEFANI Born 1969 in Fullerton, California. Stefani enjoyed several years of success with onetime ska band No Doubt. Since 2004 she has a solo career as a singer, and as fashion designer with the L.A.M.B. (Love Angel Music Baby) label. She lives with her husband, guitarist-singer Gavin Rossdale, and their two children in Los Angeles.

DITA VON TEESE Born Heather Renée Sweet in Rochester, Michigan, in 1972. She took ballet lessons from the age of four, and as a teenager was fascinated by Hollywood films of the thirties and forties. She is an icon of the New Burlesque movement, and features as a stripper, nude model, and actress. Her brief marriage to shock rocker Marilyn Manson made her famous outside the burlesque scene.

GLORIA PRINZESSIN VON THURN UND TAXIS Born in Degerloch, Stuttgart, 1960, the daughter of a count, she grew up in Togo and Somalia, where her father worked as a foreign correspondent. After leaving school, in 1980 she married Johannes, Prince of Thurn und Taxis. With her wild partying life, she acquired a reputation as the "punk princess." When her hus-band died in 1990, she took control of the family estate, cleared the debts, reconstructed the businesses, and returned them to profit. She has three children and lives in Regensburg.

TWIGGY Born Lesley Hornby in Neasden, London, in 1949. With her boyish figure and large eyes, she became the ideal beauty of Swinging London and made the miniskirt famous. Quitting

fashion after four years, she became a successful actress and singer. She married Leigh Lawson in 1988 and lives with him in London.

DIANA VREELAND Born in Paris in 1906, died in New York in 1989. Her unpar-alleled career as a fashion journalist only began at thirty-one, when she became a columnist and editor for *Harper's Bazaar*. From 1962 to 1972, she was chief editor of U.S. *Vogue*. In 1971, she was appointed special fashion consultant to the Metropolitan Museum of Art. She gained cult status mainly through her sharp comments on fashion and lifestyle.

VIVIENNE ISABEL SWIRE (VIVIENNE WESTWOOD) Born 1941 in Tintwistle, Cheshire (now Derbyshire). Until 1971, she was a teacher, and only got into fashion through her partner Malcolm McLaren, later manager of the punk rock band the Sex Pistols. They opened a boutique and invented the punk look. She brought out her first professional collection in 1981, and still runs her own internationally successful fashion business. She has taught at the University of Applied Art in Vienna and the Berlin University of the Arts as a visiting professor. Westwood is a political activist. She was awarded an OBE (1992), became a DBE (2006), and won the British Designer of Year award three times.

MRS. SIMPSON, THE DUCHESS OF WINDSOR Born plain Bessie Wallis Warfield in Baltimore, Maryland in 1895/6, died in Paris in 1986. Already divorced when she met the Prince of Wales, she eventually divorced her second husband Ernest Simpson to marry the prince, which led to his abdication as king in 1936. They married in France in June 1937, after which they shuttled between Europe and

America leading an expensive jet-set existence. When the Duke of Windsor died in 1972, the duchess retired from the public eye.

AMY JADE WINEHOUSE Born 1983 in Southgate, London, the daughter of a taxi-driving jazz enthusiast. She left school at sixteen to go to the Brit School for the Performing Arts in Croydon. She got her first recording contract at eighteen, and won five Grammies with her second album; her music mixes jazz, pop, soul, ska, and reggae. Winehouse is forever in the press's celebrity columns, not just for her music but also for her private life, particularly her drug and alcohol excesses.

RACHEL ZOE Born Rachel Zoe Rosenzweig in Yonkers, New York, in 1971. A professional stylist who began her career at *YM* magazine, she is always appropriately dressed for every occasion. Her clients include Nicole Richie, Keira Knightley, Cameron Diaz, Mischa Barton, Anne Hathaway, Selma Hayek, and Kate Beckinsale. Zoe published a book about her style secrets, and her everyday life is filmed for the *Rachel Zoe Project* reality show. She is married to a former investment banker.

CAPTIONS: TITLE PAGES

THE CLASSICS Grace Kelly wearing a fur wrap and carrying a bouquet of roses at the International Cannes Film Festival, 1955; The Duchess of Windsor wearing Mainbocher, undated; Jacqueline Kennedy enjoys herself at a picnic, c. the 1960s; Gloria Guinness at her Acapulco retreat, 1965; Carolina Herrera attends her Resort Collection, New York, 2007; C. Z. Guest poses with Joanne Connolly (right) beside the Grecian temple pool of her oceanfront estate, Villa Artemis, Palm Beach, c. 1955.; Slim Keith, undated; Audrey Hepburn, 1953; Babe Paley, 1958; Rania Al-Abdullah of Jordan poses at the annual Bambi Awards 2007, Düsseldorf

THE IT GIRLS Marchesa Luisa Casati by Adolph de Meyer, Venice, 1912; Mary Quant at her home, c. 1965; Kate Moss at Milk Studios, New York, 2008; Bianca Jagger's birthday party, July 10, 1980; Edie Sedgwick in New York, 1964/65; Sienna Miller, 2003; Louise Brooks, c. 1929; Chloë Sevigny attends a party, Paris, 2008; Twiggy, Los Angeles, 1967

THE BOMBSHELLS Brigitte Bardot, c. 1963; Marilyn Monroe poses for a portrait, c. 1956; Gwen Stefani, 2005 MTV Video Music Awards arrivals, Miami

THE MODERNISTS Coco Chanel, 1932; Jil Sander appearing on the catwalk at Milan Fashion Week, 2004; Sofia Coppola at the Costume Designers Guild Awards, Beverly Hills, 2001; Katharine Hepburn, London, 1952; Carolyn Bessette Kennedy at a fundraising gala at the Whitney Museum of American Art, New York, 1999

THE ARTISTS Frida Kahlo, *Self-Portrait as a Tijuana or Diego in My Dreams or Thoughts of Diego*, 1943, Jacques and Natasha Gelman Collection, Mexico City; Josephine Baker photographed by Peter Rose Pulham; Laglenne, *Elsa Schiaparelli*, 1932

THE DIVAS Joan Crawford in a dress with a sequined neckline, designed by Adrian, 1934; Scarlett Johansson at a premiere, London, 2005; Dita von Teese, 2006; Suzanne Lenglen on the tennis court, undated; Marlene Dietrich wearing a sleeveless dress with a chiffon bodice and floral corsage appliqués, 1937; Diana, Princess of Wales attending a gala evening, London, 1995, wearing a dress designed by Jacques Azagury

THE ECCENTRICS Anna Piaggi attends a gala at the Victoria & Albert Museum, London, 2007; Isabella Blow attends a party, London, 2007; Diana Vreeland, New York, 1974; Björk performs at the Apollo, Manchester, 2008; Grace Jones, New York, 1983

THE CANDY GIRLS Rachel Zoe during Mercedes-Benz Fashion Week, New York, 2008; Kylie Minogue performs during the opening of the Sydney 2000 Paralympic Games at Sydney Olympic Park; Sarah Jessica Parker, aka Carrie Bradshaw, on the set of *Sex and the City*, New York, 2004

THE REBELS Agyness Deyn during London Fashion Week, 2008; Princess Gloria von Thurn und Taxis, New York, 1987; Amy Winehouse arrives at the BRIT Awards 2007 at Earls Court, London; Courtney Love at the MTV Video Music Awards, New York, 1995; Vivienne Westwood, undated

THE CHAMELEON Madonna during the MTV Europe Music Awards, Lisbon, 2005

BIOGRAPHIES Marilyn Monroe, c. 1953

Frontispiece: CLARENCE SINCLAIR BULL/MGM/The Kobal Collection/ WireImage.com; pages 12/13 f.l.t.r.: RDA/Getty Images (Grace Kelly); O. Gremela (The Duchess of Windsor); Michael Ochs Archives/Getty Images (Jacqueline Kennedy Onassis); keystone, Vogue, April 1965 (Gloria Guinness); Andrew H. Walker/Getty Images (Carolina Herrera); Slim Aarons/Hulton Archive/Getty Images (C.Z. Guest); keystone/Getty Images (Babe Paley); JOHN ENGSTEAD/ PARAMOUNT/The Kobal Collection/WireImage.com (Audrey Hepburn); John Engstead, 1945. Courtesy Leonard Stanley and Majorie Richardson (Slim Keith); Karl Lagerfeld for Bambi via Getty Images (Rania Al-Abdullah of Jordan); page 14: Art Rickerby/Time & Life Pictures/Getty Images, 1963; page 15: Paul Schutzer// Time Life Pictures/Getty Images; page 16: Tom Wargacki/WireImage.com; page 17: Art Rickerby//Time Life Pictures/Getty Images, 1962; page 19: Condé Nast Archive / Corbis (left), Popperfoto/Getty Images (right); page 20: Keystone Features/Getty Images; page 21: Sunset Boulevard/Corbis; pages 22/23: Paramount Pictures/ Courtesy of Getty Images; page 24: Peter Kramer/Getty Images; page 25: MJ Kim/ Getty Images; page 26: Michael Ochs Archives/Getty; page 27: Victor Blackman/ Express/Hulton Archive/Getty Images; page 28: Sharland/Time Life Pictures/Getty Images; page 29: RDA/Hulton Archive/Getty Images; page 31: Horst P. Horst. Condé Nast Archive/Corbis; page 33: Cecil Beaton, Vogue, April 15, 1970; pages 34/ 35: John Engstead, 1945. Courtesy Leonard Stanley and Majorie Richardson; page 37: Bert & Richard Morgan/Getty Images; page 38: Bettmann/CORBIS; page 39: Sharland/Time & Life Pictures/Getty Images; page 40: Dimitrios Kambouris/ WireImage.com; page 41: Bettmann/Corbis; pages 42/43 f.l.t.r.: Image of the Marchesa Casati © Ryersson & Yaccarino/The Casati Archives/ www.marchesacasati.com (Marchesa Casati); Keystone/Getty Images (Mary Quant); Stephen Lovekin/Getty Images for Agent Provocateur (Kate Moss); David McCabe (Edie Sedgwick); Nick Harvey/WireImage.com (Sienna Miller); Ron Galella/WireImage (Bianca Jagger); John Kobal Foundation/Getty Images (Louise Brooks); Dominique Charriau/WireImage.com (Chloë Sevigny); Michael Ochs Archives/Getty Images (Twiggy); page 44: David McCabe; page 45: Burt Glinn. Magnum Photos; page 46: Joe Kohen/WireImage.com; page 47: Gustavo Caballero/Getty Images; page 49: Eugene Robert Richee/John Kobal Foundation/ Getty Images (left), Frank Driggs Collection/Getty Images (right); IRVING LIPPMAN/The Kobal Collection/WireImage.com (top); page 50: Ron Galella/ WireImage (large); Bettmann/CORBIS (small); page 51: Mike Lawn/Getty Images (large); Bettmann/CORBIS (small); page 52: Paul Ashby/Getty Images; page 53: Twenty8twelve (left); Mike Marsland/ WireImage.com (right); page 55: Images of the Marchesa Casati © Ryersson & Yaccarino/The Casati Archives/www.marchesacasati.com; pages 57, 58: Popperfoto/Getty Images; page 59: Michael Ochs Archives/Getty Images; page 60: Photo by Bruno Vincent/Getty Images; page 61: Gareth Davies/Getty Images (left), Elisabetta Villa/Getty Images (right); page 62: Keystone/Getty Images; page 63: Bettmann/CORBIS; pages 64/65 f.l.t.r.: CinemaPhoto/Corbis (Brigitte Bardot); Michael Ochs Archives/Getty Images (Marilyn Monroe); Dimitrios Kambouris/ WireImage.com (Gwen Stefani); page 67: Michael Ochs Archives/Getty Images (left), M. Garrett/Murray Garrett/Getty Images (bottom), Evening Standard/Getty Images (top); pages 68/69: ALEX KAHLE/The Kobal Collection/WireImage.com; page 70: Keystone France/laif; page 71: CollectionSpitzer/Sygma/Corbis (left); Cattani/Getty Images (right); page 72: Eric Jamison / Associated Press; page 73: Jason Nevader/WireImage for Blender Magazine (left), NICHOLAS ROBERTS/AFP/ Getty Images (right); page 74: Chris Polk / Associated Press; page 75: Steve Jennings/ WireImage.com; pages 76/77: Chanel Archives (Coco Chanel); PAOLO COCCO/AFP/ Getty Images (Jil Sander); Kathryn Indiek/WireImage.com (Sofia Coppola); Keystone/ Getty Images (Katherine Hepburn); Evan Agostini/Getty Images (Carolyn Bessette Kennedy); page 79: Lipnitzki/Roger Viollet/Getty Images (left), Douglas Kirkland/ Corbis/Courtesy Chanel Archives (right); page 80: Henri Cartier-Bresson/Magnum Photos/Courtesy Chanel Archives; page 81: Man Ray Trust ADAGP Paris 2009/Courtesy Chanel Archives; page 82: Dimitrios Kambouris/WireImage.com; page 83: Nicolas

Guerin/Corbis (left), Eric Ryan/Getty Images (right); page 85: © dpa – Bildarchiv, page 87: Popperfoto/Getty Images; page 88: Bettmann/Corbis; page 89: Alfred Eisenstaedt//Time Life Pictures/Getty Images; page 91: Arnaldo Magnani/ Getty Images; pages 92/93: Rafael Doniz (Frida Kahlo); Peter Rose Pulham (Josephine Baker); Laglenne (Elsa Schiaparelli); page 95: Hulton Archive/ Getty Images (left and bottom); Walery/Getty Images (right top); page 96: Photo Piaz; page 97: Archiv Snark (large); Photo Toulgouat, Paris (small); page 98: Archivio CENIDIAP-INBA; Mexico City; page 99: Bernhard G. Silberstein (large); Mayo brothers, with the kind permission of C. Stellweg, New York (small); page 100: akg-images, Berlin; page 101: Courtesy George Eastman House; pages 102/103: Hulton Archive/Getty Images (Joan Crawford); Tim Whitby/wireimage.com (Scarlett Johansson); Verlagsarchiv (Suzanne Lenglen); Mike Marsland/WireImage.com (Dita von Teese); Scotty Welbourne/John Kobal Foundation/Getty Images (Marlene Dietrich); Tim Graham/Getty Images (Diana, Princess of Wales); page 105: Russell Ball/John Kobal Foundation/Getty Images (left), Bert Six/John Kobal Foundation/Getty Images (right); page 106: Dominique Charriau/ WireImage; page 107: Ferdaus Shamim/WireImage.com; page 108: Nick Harvey/WireImage; page 109: Courtesy of www.dita.net / Photographer Danielle Bedics; page 111: Roger Viollet/Getty Images (left), Alfred Eisenstaedt//Time Life Pictures/Getty Images (right); page 112: Eugene Robert Richee/John Kobal Foundation/Getty Images; page 113: GEORGE HURRELL/UNITED ARTISTS/The Kobal Collection/WireImage.com; page 114: Jacqueline Arzt/Associazed Press; page 115: Tim Graham/Getty Images; page 117: George Pimente/wireimage.com; page 119: Underwood & Underwood/Corbis (left), Hulton-Deutsch Collection/Corbis (right); pages 120/121 f.l.t.r.: Dave M. Benett/Getty Images (Anna Piaggi); Dave Benett/ Getty Images (Isabella Blow), Arnold Newman/Getty images (Diana Vreeland); Shirlaine Forrest/WireImage.com (Björk); Tom Wargacki/ WireImage.com (Grace Jones); page 123: Maurits Sillem/Getty Images; page 124: Laura Rauch/Associated Press; page 125: Laurent Rebours/ Associated Press; page 126: © Adrees Latif/Reuters/Corbis; page 127: Mike Marsland/WireImage.com; page 128: Dave Benett/Getty Images; page 129: Getty Images for Avolus; page 131: George Hyningen-Heune, Diana Vreeland Archives; page 132: Ron Galella/WireImage.com; page 133: Bettmann/Corbis (left), rex features (right); pages 134/135: George Napolitano/FilmMagic (Rachel Zoe); Jamie Squire/ALLSPORT (Kylie Minogue); James Devaney/WireImage (Carrie Bradshaw); page 136: James Devaney/WireImage; page 137: Tom Kingston/WireImage (left), James Devaney/WireImage (right); page 138: Brian Ach/WireImage; page 139: James Devaney/WireImage; page 141: Andy Buchanan/WireImage.com (left), Paulo Sutch (bottom), Jo Hale/Getty Images (top); page 142: Rabbani and Solimene Photography/WireImage; page 143: Dimitrios Kambouris/ WireImage.com; pages 144/145: Fred Duval/FilmMagic (Agyness Deyn); Ron Galella/WireImage.com (Gloria von Thurn und Taxis); Gareth Cattermole/Getty Images (Amy Winehouse); Kevin Mazur Archive/ WireImage (Courtney Love); Christian Shambenait (Vivienne Westwood); page 147: Myrna Suarez/Getty Images (left); Jon Furniss/WireImage.com (right); page 149: Ron Galella/WireImage.com; page 150: Kevin Mazur Archive/WireImage; page 151: © Jeffrey Thurnher/Corbis (left), Russell Einhorn/Liaison (right); page 153: Lorenzo Santini/WireImage (left); page 154: © Condé Nast Archive/Corbis; page 155: Polly Borland/Hulton Archive/ Getty Images; page 156: Fred Duval/WireImage; page 157: Mark Allan/ WireImage; page 159: Frank Micelotta/Getty Images for MTV; page 161: Getty Images (left), David McGough/DMI/Time Life Pictures/Getty Images; page 162: © Deborah Feingold/Corbis; page 163: AP Photo / Gill Allen; page 164: Michael Ochs Archives/Getty Images